F<small>the</small>ACE<small>in the</small>CORNER

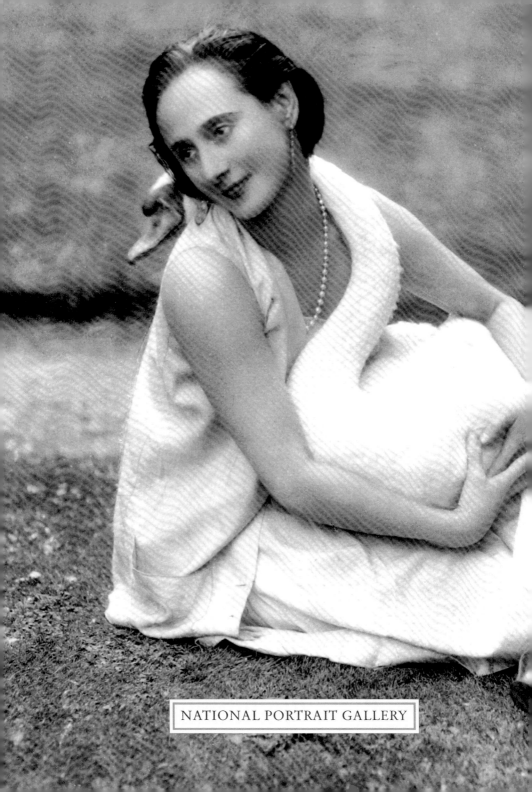

THE
FACE
IN THE
CORNER

Animals in Portraits
from the
Collections of the
National Portrait
Gallery

ROBIN GIBSON

Published in Great Britain by
National Portrait Gallery Publications
National Portrait Gallery
St Martin's Place
London WC2H 0HE

ISBN 1 85514 230 9

A catalogue record for this book is available from
the British Library.

Publishing Manager: Jacky Colliss Harvey
Picture Research: Susie Foster
Project Manager: Ariane Bankes
Designed by Simon Loxley
Printed by Grillford Ltd

For a complete catalogue of current publications,
please write to the address above.

Frontispiece: Anna Pavlova with Jack
by Lafayette, 1927
NPG x49320

Front cover: Catherine 'Kitty' Fisher
by Nathaniel Hone, 1765
NPG 2354

Contents

Picture Credits

The *Face in the Corner* is about the various animals that appear in portraits in the National Portrait Gallery, but it is also about the owners of the animals who commissioned the portraits. If we take the presence of horses in portraits for granted as the one universal means of transportation until early this century, there are many other reasons why someone should wish to have a particular animal included. In a sixteenth- or seventeenth-century painting, the animal almost certainly carried some symbolic significance and formed part of the artist's commentary on his subject. Later, in portraits of the landed gentry, an animal might serve as an indication of lifestyle and status or, in a similar way, be little more than a fashion accessory in a portrait of a lady. Partly thanks to better documentation, it is not until well into the eighteenth century that we can determine whether the animal is a treasured pet and companion rather than simply part of the general *mise-en-scène*. Whatever the reason for inclusion, we may be sure that the animal's significance is in some way personal to the message that the artist and his sitter wished to convey to the viewer. Thus in portraits which, like many of those in the National Portrait Gallery, were created for public and official purposes, animals tend to appear far less frequently.

Portraiture is possibly the most accessible branch of the visual arts and the spectator can relate directly to and form opinions on the appearance, character and status of the subject perhaps more quickly than with any other form of painting or sculpture. For that reason it is easy to take the presence of animals, even if not

always confined to the corner of pictures, for granted, and few commentators on portraiture have devoted any attention to them. 'People and their pets'-type pictures, where the animal participates in the portrait on more or less equal terms with its human companion, are a comparatively recent phenomenon and coincide with a general shift towards greater informality in portraiture. The trend was perhaps begun by the gifted Victorian animal painter Sir Edwin Landseer, but only fully comes into its own with the rise of photojournalism, as the plates in this book demonstrate. With very few exceptions, modern painting has taken little interest in animals and the concurrent and gradual decline of portraiture as a major art form seems to reflect this.

Dogs in particular have been the companions of man since pre-civilisation and their inclusion in a portrait may seem, in a sense, no more remarkable than the usually essential ingredients of clothes or furniture. The ownership of land since time immemorial has entailed not only money and power and the country houses and portraits with which to commemorate it, but also hunting and shooting and the dogs and hounds that were a necessary part of this privileged activity. In medieval times, hunting, usually with elegant and aristo-cratic greyhounds, had been an essential ingredient of the courtly tapestries and manuscript illuminations of the period. In the Netherlands in the seventeenth century and in eighteenth-century Britain in particular, schools of painting developed which were devoted solely to the genre of hunting in one form or another. We should now think it strange indeed to visit a great country house and not find successive portraits of the head of the family with his dogs or horses, or with his friends and retainers out fox hunting or returning from a day's shoot.

Portraiture, however, is not all social history, and in the fifteenth century it was as a cultural phenomenon, one manifestation of the visual arts and of easel painting in particular, that it began to appear as a genre in its own right. For Flemish artists, it was only one step from the inclusion in an altarpiece of a portrait of the donor, the man who had paid for the picture, to painting a separate picture of the man in his own right. Animals also first made their appearance in Gothic and early Renaissance religious paintings, but usually with a symbolic significance which would perhaps inevitably be carried over into portraiture for several hundred years. Dogs had been largely ignored by the Bible, except as scavengers, but they (and horses) were characterised by the Roman author Pliny the Elder as the most faithful friends of man. It was this classical and increasingly pantheistic view which held sway in the late Middle Ages, and

fidelity remained the primary significance of the dog's appearance in early religious painting and portraiture. Its meaning could be further refined, so that a white greyhound so often seen with the three kings in paintings of the Adoration of the Magi is not only an emblem of fidelity to the new-born Saviour, but with its courtly associations is also a sign of the visitors' high birth, and its whiteness a symbol of purity and blessedness. Dogs were also the emblems of St Eustace and St Hubert, patron saints of hunting, and by an elaborate pun, of one of the most powerful religious orders, the Dominicans (*Domini canes* – the dogs of the Lord). Cats fared badly. They were seen as creatures of the night and thus associated with the devil, witches and lechery, or at best with sloth, since they were inclined to sleep during the day. For that reason, and though they appear in seventeenth-century Dutch genre paintings, they are scarcely ever seen in religious works or (with one notable exception) in portraiture until the eighteenth century.

Birds, however, are frequently found in early Renaissance paintings, and although never a common feature of portraiture, their presence there is often a survival of their early emblematic significance. The goldfinch, well known in representations of the Madonna and Child, was emblematic of the Passion of Christ because it lived and fed on thistles, which were equated with the crown of thorns. Its bright plumage in any case made it a popular pet and it is sometimes seen in portraits of children, a general symbol of innocence. In later seventeenth- and eighteenth-century portraits it is just as likely to be any wild bird, often seen rather cruelly tied to a string, and really of no greater significance than any other wild creature kept as a pet. Parrots, including cockatoos and parakeets, however, were expensive imports; they were meant to be noticed and since the fifteenth century had acquired a double meaning. In that they could imitate their master's voice, their significance was similar to that of the faithful dog: indeed their inclusion in paintings of the Madonna was said to be because they could say 'Ave'. A green parrot, in a somewhat convoluted simile which survived into seventeenth-century emblem books, was also a symbol of virginity because the green of its plumage never became wet when it rained, unlike the green foliage and grass of mother earth. As such, a green parakeet is seen perching on another later symbol of virginity, an orange tree, in the portrait by Largillière of the children of James II [plate 6].

The lamb or sheep carries a similarly elaborate significance as far as portraits are concerned. An established Christian symbol for Christ, it was also the emblem of St Agnes and in a portrait can occasionally be linked with her name or her virtues. In seventeenth-

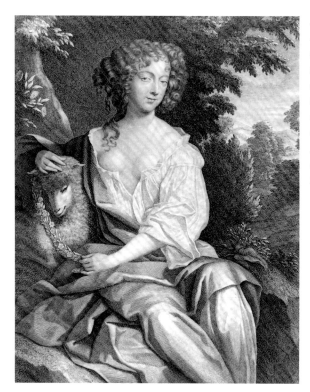

Fig. 1.
Engraving
after a portrait
of Nell Gwyn
as 'Spring'
with a sheep,
c.1670, by
Gerald Valck,
32 x 25cm
(12¹/₂ x 10").
NPG 3811

century emblem books, however, its interpretation is specifically classical, and refers to Aries, the appropriate sign of the zodiac. Aries is the constellation of spring time, and a ram or sheep shown in a portrait being garlanded with flowers by a Restoration beauty such as Nell Gwyn [fig. 1] is a sign that we are required to view the lady in the guise of *Primavera*, the embodiment of youth and fecundity. By the eighteenth century the sheep's significance has declined to the purely pastoral and it is a common feature in rococo portraits of ladies as Arcadian shepherdesses or may even appear simply as a cuddly pet in some portraits of children.

The first notable animal in European portraiture is without doubt the little lap dog in the foreground of the famous Arnolfini wedding portrait in the National Gallery by the Flemish artist Jan van Eyck. Painted in 1434, the dog is of course, like almost everything else in the painting, a symbol, but, again like everything else in this most perfect example of early Renaissance humanism, also a totally natural and believable presence. Influences spread slowly and it was not until a hundred years later that the great Italian painter Titian would begin to include dogs in many of his portraits – from

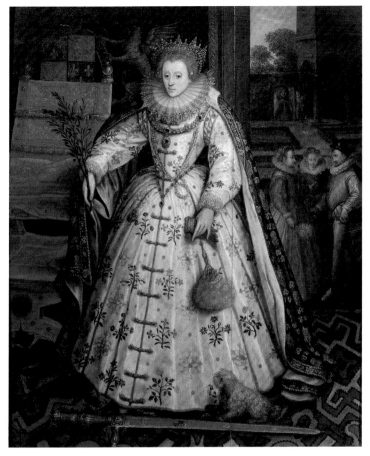

Fig. 2. Elizabeth I, by Marcus Gheeraerts the Elder, c.1580–85.
Oil on panel, 45.7 x 38.1cm (18 x 15"). © Private collection

the magnificent racing dog of the Emperor Charles V to the little toy spaniel curled up on the table next to the Duchess Eleanora Gonzaga. Indeed, British painting was still at this time in its infancy, and not until Van Dyck arrived here, nearly two hundred years after the painting of the Arnolfini portrait, would a dog in a British portrait achieve anything more than heraldic significance.

This lamentable fact is purely a reflection of the off-shore status of British painting and in no way of the status of the British pet. Sixteenth-century Britain is as fertile a source of famous dog stories as any century since. Payments for Henry VIII's spaniel Cutte were recorded in the royal accounts, and across the border Mary Queen of Scots was an even more celebrated dog-owner. While she was

Queen, two loaves a day and 'blue velvet for collars for the Queen's little dogs' had been provided. In captivity, she wrote to the Archbishop of Glasgow asking about a couple of 'pretty little dogs' from Lyons: '... my only pleasure is in all the little animals I can get. They must be sent in baskets, well stored so as to keep them warm.' It was one of these little dogs that accompanied her, concealed under her skirt, to her execution. Spotted with her blood, the faithful beast was discovered between her severed head and trunk and could only forcibly be separated from her corpse. More famous by name was Sir John Harington's (1561–1612) dog Bungey, who on several occasions carried letters from his house near Bath to the court at Greenwich and back again. Bungey also transported two flagons of sherry across country, hiding one when he found it too heavy and returning for it later; and, more practically, he found Sir John's purse full of gold when he had lost it. Harington was so proud of Bungey that he had his picture engraved as frontispiece to his translation of Ariosto's *Orlando Furioso* in 1591 and later wrote Bungey's biography and sent it to another dog-lover, Henry, Prince of Wales.

These stories can only have served to reinforce the dog's significance as a symbol of fidelity, but none appear in their masters' portraits. One of the few exceptions to the general rule about the lack of animals in early British portraiture is an enchanting small panel of Mary Stuart's hated persecutor, Elizabeth I, which shows an adoring small white lap dog of the same bichon type that Mary would have owned and which had also appeared in the Arnolfini portrait [fig. 2]. Mention must also be made of the great exception to the rule about cats: the remarkable portrait of Henry, 3rd Earl of Southampton, by John de Critz, painted in 1603 [fig. 3]. It commemorates Southampton's imprisonment in the Tower, and whether the cat was a real one or not, its function in the picture is to underline the prisoner's solitude, the cat being his only companion during his captivity. While there may in its presence be a trace of the cat's old associations with witchery and bad luck, it demonstrates nevertheless a rather modern and more psychological use of animal symbolism, more commonly found in much later portraits. In the late Victorian portrait of Charles Reade, for instance [plate 19], the companionship of the dog and the cats helps to emphasise the essential isolation necessary to the creative writer, as it does in much the same way for the enforced loneliness of the sick in Sir Francis Chantrey's amusing self-portrait drawing [plate 15].

With the presence in the 1630s of Sir Anthony Van Dyck at the court of Charles I, dogs (though not cats) in portraits become a

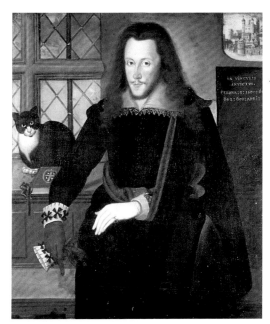

*Fig. 3. Henry
Wriothesley,
3rd Earl of
Southampton, by
John de Critz, 1603.
Oil on canvas,
109.2 x 87.6cm
(43 x 34¹/₂").
Private collection*

commonplace. The trigger for this may to an extent have been Van Dyck's study of the works of Titian, most noticeable in his full-length portraits of men of power and influence, such as the Duke of Richmond with his huge greyhound in the Metropolitan Museum, New York. There seems little doubt, however, that Charles's French queen, Henrietta Maria, also played a significant role, and the toy spaniels, which were almost certainly her introduction to the court, can be seen romping around in all Van Dyck's paintings of the Royal Family and children. Paradoxically, these toy spaniels, which came to be known as King Charles's and can be found in so many paintings of Charles I's family, are not found in any painting of his son Charles II, after whom they were named, with the solitary exception of the one reproduced here, made when he was a baby [plate 2].

Despite the spaniels' by now rather superficial symbolism as emblems of fidelity, their appearance in Van Dyck's paintings introduces another strand to the saga of animals in portraiture, that of the fashion accessory. Fashions for certain breeds of dog are a well-known phenomenon, and with their royal associations, toy spaniels have remained popular domestic pets and have been one of the most enduring breeds to figure in both British and foreign portraiture, especially with women and children. They may be found again and again in portraits throughout the seventeenth and eighteenth centuries and they make a determined revival in the

nineteenth, when the young Queen Victoria had her spaniel Dash painted by Landseer. Their only serious rival in the seventeenth century for inclusion in portraits of women seems to have been the small Italian greyhound [plate 5], an even more delicate import than the toy spaniel, but which lent an elegant and slightly more sporty air to the sitter, especially appropriate for classically orientated baroque symbolism such as that of the goddess of hunting, Diana.

The standard symbolism in baroque portraiture of the dog's fidelity to its master continues the basically Christian visual metaphor of medieval times, and it is significant that its last (and most magnificent) gasp in the National Portrait Gallery's collection is to be found in the 1695 portrait by a Catholic painter, Largillière, of the Catholic children of James II, the 'Old Pretender' and his sister [plate 6]. As usual in such dynastic portraits, the boy (and heir) is given a hunting dog of some splendour for his companion while the little girl, like the daughter in the Vyner family [plate 4], has to make do with some emblematic flowers as more suited to her sex and status. In this case, the message could not be more clear: the exiled prince is seeking the fidelity of his subjects over the English Channel; his sister, holding a sprig of orange blossom, is a virgin and is (or will soon be) looking for a suitable husband. The splendid brass collar worn by the greyhound carries in this case no inscription, though in many such portraits it would have been inscribed with the name of its owner, thus proclaiming not only the identity of the portrait for all to see but also the sitter's wealth and dominion over those claiming loyalty to him.

There is of course no evidence whatsoever that the dogs shown in the Largillière portrait belonged to the children, and many such emblematic pets, however realistically painted, were patently of the 'rent-a-dog' variety. Though the average princely or ducal kennels would have had no trouble in rustling up a suitable breed for a particular portrait, in many cases it seems probable that such animals no more belonged to the subject of the portrait than did the classical columns or orange trees in the picture. Indeed, in the hands of less skilled artists, animals are sometimes scarcely identifiable as anything other than dog- or horse-shaped accessories. This practice has of course never totally disappeared. In an amusing essay entitled 'Borrowed Dogs', the contemporary American photographer Richard Avedon, commenting on the artificiality of much photography of the previous generation, remembers with embarrassment how his parents would invariably beg the loan of a dog, sometimes from complete strangers, before taking a family photograph. They imagined, no doubt, like many before them, that the inclusion of an

imposing beast would lend both the family and the photograph a certain dash and distinction.

The apparently heavy-handed, though to the contemporary viewer totally unremarkable, symbolism of the baroque was almost invariably practised in seventeenth-century Britain by painters from abroad and frequently from Catholic countries. In the eighteenth century, the Age of Reason, and in particular in a Protestant and liberty-conscious Britain, it could not survive, and the native painters of the first half of the century such as Hogarth looked to the genre painting of seventeenth-century Protestant Holland for their inspiration. The conversation pieces of Hogarth and of his rivals such as Gawen Hamilton [plate 7] are full of dogs and cats included quite straightforwardly as part of the domestic scene. Cats indeed undergo a quite extraordinary U-turn in their fortunes. By the middle of the century, kittens, both cuddly and playful, are frequently seen in portraiture throughout Europe as suitable accessories for portraits of little girls, presumably under the assumption that that is what little girls are like – or, possibly, what they will grow up to be. Such unconscious sexual innuendo has been shown to play an increasing role in eighteenth- and early nineteenth-century portraiture where the elements of a painting were no longer dictated by traditional conventions and symbols. In the case of the courtesan Kitty Fisher, however [plate 11], the kitten seen fishing for golden opportunities is quite blatantly much more than a mere pun.

In an era of overriding humanism (and, it must also be admitted, of better documentation), pets in portraits were now, as often as not, not simply accessories but specifically identifiable creatures with known names, lifespans and allegiances. The fact that many animals in portraits from the early eighteenth century onwards now become identifiable pets is, of course, also partly due to the rise of a far more settled and affluent society where working dogs and cats stood more chance of becoming household familiars or indeed prized sporting assets. To meet this development, there now began to appear in Britain a number of animal and sporting painters, including artists like Hogarth's near-contemporary, John Wootton, and a little later the greatest of them all, George Stubbs. We know from a family group that Wootton owned his own Italian greyhound, but apart from painting the racehorses and hunts of his aristocratic patrons, he also painted their pet dogs. For Edward Harley, Earl of Oxford, he painted at least six portraits of the family's dogs, including the overweight and ageing spaniel Casey on a grandiose red cushion, and for the King's minister, Sir Robert Walpole, he did a mock-heroic portrait of his Italian hound, Patapan.

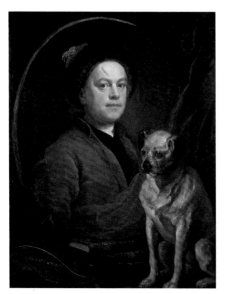

Fig. 4. Self-portrait with Trump, *by William Hogarth, 1745. Oil on canvas, 90.2 x 69.8cm (35¹/₂ x 27¹/₂"). Tate Gallery*

Fig. 5. X-ray of Self-portrait painting the Comic Muse (detail), *by William Hogarth, c.1757. Oil on canvas, 45.1 x 42.5cm (17³/₄ x 16³/₄"). NPG 289*

It is against this background that the independent-minded Hogarth deployed his beloved pugs. The breed was originally introduced into Britain from Holland by William of Orange, and Hogarth is known to have possessed at least three pugs, of whom Trump, who figures so prominently in the famous self-portrait in the Tate Gallery [fig. 4], is the best known. Trump's presence reflects not only Hogarth's love and deep respect for the animal, but with his independent and no-nonsense outlook on life is also a metaphor for the artist himself. As such, Trump appears on his own as the artist's commentator in several other Hogarth paintings, for instance wearing a wig and mocking the pomposity of naval officers in the group portrait of *Captain Lord George Graham in his Cabin* (National Maritime Museum). What is probably a later pug makes a surprising hidden appearance in the National Portrait Gallery's *Self-portrait painting the Comic Muse* [fig. 5]. Visible only in X-ray – probably after Hogarth decided he might have overstepped the mark – the pug is seen urinating on the artist's behalf on a pile of old master paintings; a succinct comment on those collectors who preferred second-rate foreign imports to contemporary works by British artists.

Trump becomes in a sense Hogarth's *alter ego*, though in a much

Fig. 6. John and Mary Wilkes, by Johann Zoffany, c.1782.
Oil on canvas, 126.4 x 100.3cm (49³/₄ x 39¹/₂").
NPG 6133

more flamboyant manner than other artists' pets. Sir Alfred Munnings [plate 32] used one of his dogs in a satirical painting two centuries later, but it is perhaps only Landseer in the nineteenth century and Maggi Hambling [plate 38] in the present day who have to a similar extent used their own and other animals to reflect their innermost ideas and indeed their own personalities. The German-born and sober-minded Zoffany clearly derived simple pleasure from including his own white German spitz, Poma, in some of his paintings [fig. 6] so that she becomes a sort of covert signature. It is not clear whether Gainsborough may also have included his own dogs in some of his work, though they appear in portraits of his own family and on their own in the enchanting portrait of the two little dogs *Tristram and Fox* in the Tate Gallery. Gainsborough's genius as a painter of dogs has seldom been noticed, but stylistically in this he lies somewhere between Stubbs and Landseer. He also painted a portrait of his musician friend Carl Friedrich Abel's two white

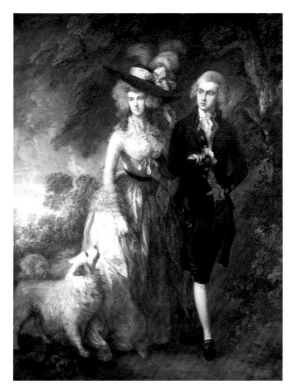

German spitzs, a breed which appears in the famous *Morning Walk* in the National Gallery [fig. 7] and seems to have been one of the most fashionable dogs of the late 1770s and 1780s. It seems quite likely that the paintings of Gainsborough and Zoffany, not to mention the influence of their expatriate German friends in the world of music and indeed of a German queen, Charlotte, were to a substantial extent jointly responsible for the popularity of the German spitz, often referred to at the time as a Pomeranian or fox dog. Fifty years later, the paintings of Landseer would do much the same for the increasing popularity of the Scottish deerhound and the Newfoundland.

The association of the subject or indeed the artist of a portrait with an identifiable pet immediately adds a further dimension to our understanding of the characterisation. Admittedly, apart from proclaiming 'this is also a nice person who likes animals/ hunting/shooting', it would probably in most cases only have been of significance to friends and family who knew the animal in question. It was clearly of importance to the sitter, however, and we find the poet William Shenstone [plate 10] wondering whether

his 'faithful Lucy' should be moved a bit to the left in order to improve the composition of his portrait, and the painter Angelica Kauffmann noting in her accounts, 'likewise the portrait of the pet dog' specifically mentioned for inclusion in her portrait of Thomas Jenkins and his niece [plate 14]. In the case of a subject like Sir Walter Scott, whose Scottish deerhound Maida had become nationally famous, not only from the reports of pilgrims to his house at Abbotsford but also through his writings, the artist Sir William Allan apparently felt that it would be unthinkable to exclude the dog, even though he had by all accounts died several years earlier [fig. 8].

The corollary to this is that the animal, as well as saying something about the subject, may also be representing someone absent from the portrait, and thereby conveying some sort of hidden message. How many people at the time would have known that Lady Caroline Lamb's little dog Phyllis and its jewelled bracelet [plate 16] were in fact gifts from a lover and therefore a semi-public admission, indeed a commemoration, of an illicit affair? In the portrait of Charles Reade [plate 19], his mistress's dog Puff and her faintly sketched-in portrait on the wall stand in for Mrs Seymour, his lifelong companion, who probably for reasons of propriety could not herself be included in the portrait. The same is true to a slightly lesser extent of the photograph of Ellen Terry [plate 23], since the

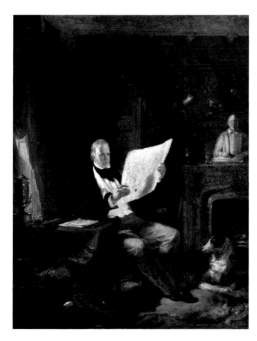

Fig. 8. Sir Walter Scott, by Sir Willliam Allan, 1831. Oil on canvas, 81.3 x 63.5cm (32 x 25"). NPG 321

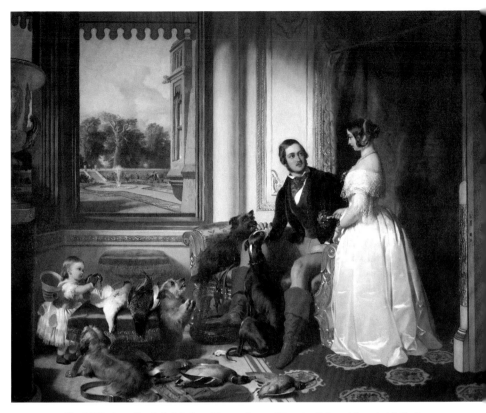

Fig. 9. Windsor Castle in Modern Times: *Queen Victoria, Prince Albert (with Eos) and Victoria, Princess Royal, by Sir Edwin Landseer, 1840–43. Oil on canvas, 113 x 143.8cm (44¹/₂ x 56⁵/₈"). The Royal Collection © Her Majesty the Queen*

dogs shown with her were an integral part of her relationship with Sir Henry Irving. Stretching the analogy further, we might speculate that the little dachshund Clytie shown in Karsh's photograph of Benjamin Britten and bearing the name of Peter Pears's singing teacher, is also in a way a symbol of the composer's private life and of his relationship with Pears.

From absent lover to surrogate lover is only a short step, and a quick glance through the portraits in this book reveals how many distinguished pet owners were if not actually bachelors, at least widowed, divorced, or past the passionate affairs of their youth. One such 'passionate' relationship one feels must probably have existed between the 'difficult' bachelor poet William Shenstone and his 'faithful Lucy', and certainly between Landseer [plate 18], who never married, and some of his many dogs. The understanding and

pathos with which Landseer was to imbue his portraits of dogs is unparalleled in art history and Lassie and Rifa appear in his only self-portrait on intimate and equal footing with himself. For Elinor Glyn [plate 29], now an ageing beauty settling down to an active retirement after a career littered with affairs, the two reliable cats came no doubt to replace a series of unreliable men. For Ethel Smyth and Vita Sackville-West [plates 24 and 31], two kindred spirits struggling to come to terms with the social and psychological consequences of their attachments to other women, their relationships with their beloved dogs Marco and Martha seem to have represented a depth of emotional involvement and provided the stability and constancy that they were unable to find elsewhere. To the Duke and Duchess of Windsor [plate 35], childless and exiled in a foreign country, the ever-growing retinue of pugs must have constituted some sort of substitute for the family they never had. And what is one to make of the great ballerina Anna Pavlova and her swan Jack, whose amorous cavortings would have seemed indecent in any other animal [plate 28]?

It was the dashing poet Lord Byron who was perhaps first responsible for giving public respectability to such romantic attachments. Newly imported Newfoundland dogs such as his beloved Boatswain had begun to achieve something of a legendary status for their life-saving exploits during the Napoleonic Wars. When Boatswain died after a fit in 1808 at the age of five, the poet poured out his grief in misanthropic verse: 'To mark a friend's remains these stones arise; I never knew but one, and *here* he lies' – and then arranged for an elaborate monument with a lengthy panegyric to rise at Newstead Abbey, his ancestral home. Boatswain and Sir Walter Scott's deerhound Maida rapidly set a fashion for Newfoundlands and deerhounds which was quickly taken up by Queen Victoria and Prince Albert and their favourite painter, Landseer. The Victorian court seems to have considered it far too frivolous to include dogs in any formal portrait; indeed none ever appear in any portrait by the principal court painter, Winterhalter. The Royal Collection is nevertheless full of informal family groups and hundreds of portraits of dogs by Landseer and others and proves Queen Victoria to have been one of the most enthusiastic dog-owners ever [fig. 9]. She writes about them in her diaries and letters in exactly the same terms in which she writes about her family, though it is possibly only her King Charles spaniel Dash and Prince Albert's greyhound Eos who receive the full Boatswain honours. The many paintings, photographs and the detailed documentation provided by the royal kennels make it possible to trace not only

individual animals, but also the changing fashions for different breeds which rapidly filtered down through the rest of society. In the 1870s and 1880s, the deerhounds are replaced by Border collies [see plate 22], the toy spaniels firstly by Skye terriers (the Scottish influence again) then by dachshunds and fox terriers and finally by Pomeranians. It was the little Pomeranian Turi whose company Victoria requested as she lay dying.

Her daughter-in-law Alexandra favoured the new oriental breeds, the Pekinese and Japanese Chin [plate 25], and borzoi briefly replaced the royal greyhounds and deerhounds. Edward VII, a keen shooting man, and his son George V popularised Clumber spaniels and Edward was devoted to his fox terrier Caesar, a breed first given to him by his mother in the 1870s [plate 26]. George VI and his family's devotion to the Welsh corgi brought a whole new perspective to the Royal Family's reputation as dog-lovers [plate 39] and stories continue to occupy the press about Prince Charles's Jack Russell and Princess Anne's bull terrier. Royal influence on fashion is perhaps no longer as powerful as it once was. The royal corgis singularly failed to set a fashion, except perhaps for a brief period in the 1950s, and Jack Russells and bull terriers had been popular for many years before being taken up by their royal owners. Fashions are now more likely to be set by modern advertising. It can be no coincidence that the two most recent dogs to appear in portraits in the National Portrait Gallery are labrador retrievers [fig. 10 and plate 40], currently the most popular breed as a family pet in the British Isles, but also the stars of one of the most successful advertising campaigns of the last twenty years for, of all things, a well-known brand of toilet paper.

Cats have been immune to fashion in almost every way and continue to maintain their place in the household much as they have always done. Whether it is their relative independence compared to dogs or their long association in the human mind with femininity, the message conveyed by the inclusion of a cat in a portrait will always remain subtly different from that of a dog. Perhaps something of the old superstitions still remain, but after five hundred years of British portraiture, it is still unthinkable, for example, to imagine a portrait of a monarch or a prime minister with a cat. Downing Street may have had its Humphrey, but a prime minister has a dog [fig. 10]. The image of the dog as loyal, watchful, upright and the servant of man continues to live on in people's minds unscathed.

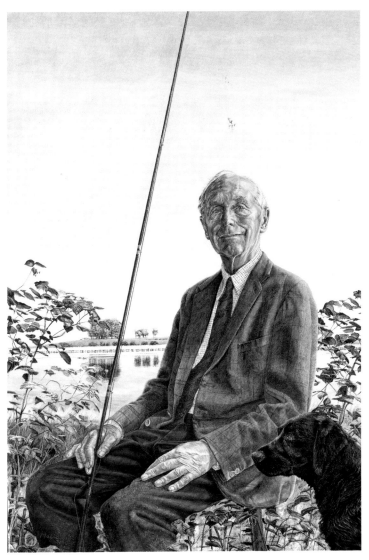

*Fig. 10. Lord Home of the Hirsel, by Suzi Malin, 1980. Oil on canvas,
118.8 x 75.6 cm (44 x 29³/₄"). NPG 5367*

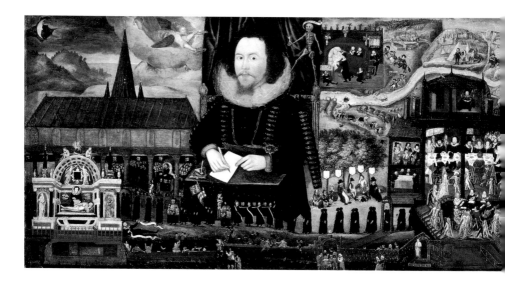

1. Sir Henry Unton (1557?-96)
By an unknown artist, c.1596
Oil on panel, 74 x 163.2cm (29⅛ x 64¼")
NPG 710

Commissioned by his widow Dorothy, this remarkable painting tells the life story of Sir Henry Unton, an Elizabethan soldier and diplomat who died during a mission to France.

The story begins at the bottom right, where after entering a house through the porch, the first scene portrays Sir Henry's early infancy. His mother, who like the rest of the important figures in the painting is portrayed larger than the other women in the room, was Lady Anne Seymour, niece of Henry VIII's Queen, Jane, and widow of the executed Earl of Warwick. This family connection with the highest in the land would have been of great importance to Unton's widow, and his father, Sir Edward, a mere country gentleman, makes no appearance in the painting at all. All the women in the room, including the nurse on the right and the two lady relatives on the left, wear costume of the date of Unton's death, rather than of the late 1550s when Sir Henry was born.

At the foot of the cradle, lying on the woven rush matting between the stool and the settee, is a little white dog. With its shaggy mane and shaved body, it is probably one of the now rare little lion dogs, a breed that was popular throughout the courts and great houses of fifteenth- and sixteenth-century Europe. Indeed Unton himself could well have brought back a dog like this as a present for his wife from his first diplomatic mission to France in 1592. Far from being excluded from the bedrooms and ladies' chambers

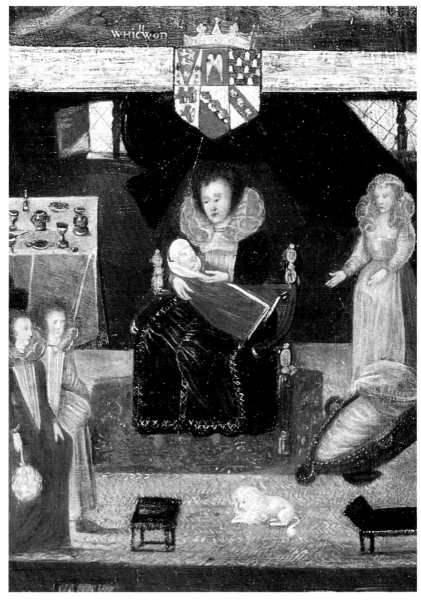

WHICWON

of the time, such dogs would have been positively welcomed in the belief that they would attract both fevers and parasites away from their owners to themselves. Indeed, it is documented that when Sir Henry was dying, the doctor sent by Henry IV of France to attend to him prescribed live pigeons to be placed on his sores for precisely this purpose.

2. Charles II as a baby (1630-85)
By an unknown artist, 1630
Oil on canvas, 119 x 91cm (47 x 36")
NPG 6403

This larger-than-life portrait of the infant heir of Charles I is probably a painting commissioned by his mother, Queen Henriettá Maria, to send to her family in France. She wrote to a friend, Mme de Saint George: 'I will send you his portrait as soon as he is a little fairer; for at present he is so dark that I am ashamed of him. [And] ... He is so fat and so big that he is taken for a year old, and he is only four months.' A later letter implies that she had sent such a portrait to her mother, Marie de Medici, and the inscription at the top of the picture is indeed in French and confirms that the prince is four months old. His being dark is less apparent, though it is well documented, and his looks were almost certainly inherited from his Italian grandmother.

Despite the lack of any royal regalia, the portrait is self-evidently a piece of political propaganda, though the central role of the little puppy in the portait is most unusual. Almost certainly painted life-size and occupying the focal point of the composition on the propped-up baby's lap, its symbolic function as the traditional emblem of loyalty to the lord and master is here overlaid with resonances of the subject's loyalty to and patronage from the heir to the throne. The dog's presence in the royal nursery as a magnet for fevers and parasites which might otherwise afflict the child is, as has already been noted, not remotely unusual and the dog would doubtless also serve where necessary as a hot-water bottle.

The liveliness and realism with which the dog is painted not only suggests that it may have been executed by a different artist from the rest of the painting, still in the 'Jacobethan' tradition, but also allows us to identify it beyond doubt as one of the toy spaniels that seem to have been as much a feature of Charles I's court as they would later be of his son's. This still seems an amazingly prophetic touch, whether on the part of the Queen or of the artist, for these are the dogs for which the future Charles II became renowned, if not notorious, and which would later bear his name. Seen here as a baby playing with the dog's ear, in years to come the King would be the subject of grumbles from his ministers that during government business he whiled away the time by trifling with his spaniels.

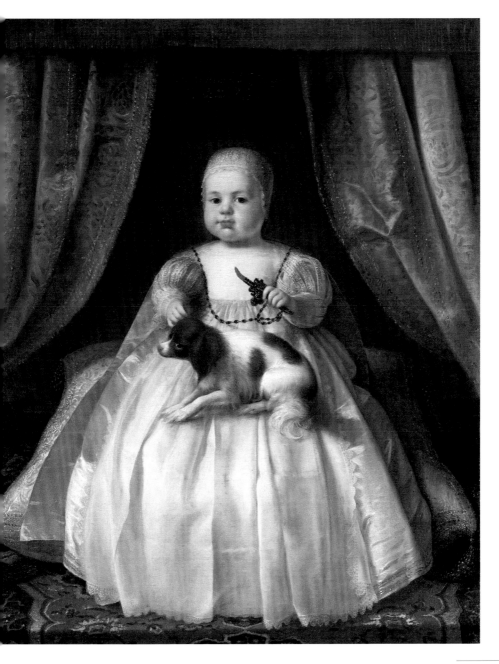

27

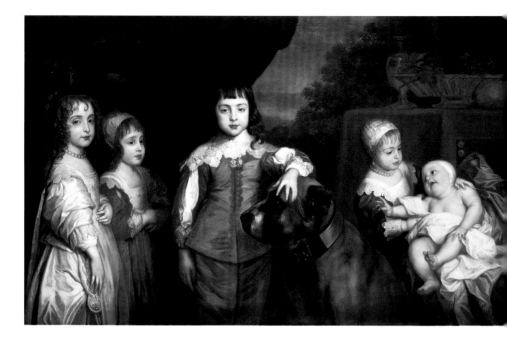

3. The Five Children of Charles I
After Sir Anthony Van Dyck, 1637
Oil on canvas, 89.5 x 176.2cm (42½ x 68¾")
NPG 267

Van Dyck's sophisticated paintings of the court of Charles I must have come as a considerable culture shock to the majority of Britons who had never travelled in Europe. Painted only seven years after the stiff and hieratic portrait of Charles II as a baby [plate 2], the young prince now dominates the centre of this elegant group of royal children, once more with a dog as accessory, though this time a rather spectacular mastiff. What cannot be seen in this reduced copy of the original full-length painting in the Royal Collection is yet another toy spaniel bouncing into the picture, as they do in almost all of Van Dyck's groups of the Royal Family.

The mastiff, while providing the usual symbol of loyalty and fidelity, nevertheless by its overwhelming presence and size seems also to suggest a symbol of power and perhaps of protection for its young charges. The mastiff had been a guard dog since Roman times, but was also the most common dog for the then hugely popular sports of bear- and bull-baiting, which had made even as well known a philanthropist as Edward Alleyn, founder of Dulwich College, immensely rich. He was empowered as Master of the Royal Game of Bears, Bulls and Mastiff Dogs to requisition any mastiffs he chose; as a result, they had by the end of James I's reign become something

of an endangered breed. The mastiff's presence here, as well as reflecting Charles I's passion for baiting, may also by now have been something of a status symbol.

Charles II by contrast showed little interest in this cruel sport and will always be remembered for the spaniels that bear his name. In 1662, the Serjeant of Hawks was paid twenty pence a day for walking the King's spaniels and £7 for a suitable livery. The story is told, much like those in currency about today's royal corgis, of a loyal gentleman who was bitten by one of the spaniels and exclaimed, 'God bless your Majesty! but God damn your dogs!' In 1685 Bishop Burnet was shocked by the fact that even as the King lay dying, the royal bed was, as usual, alive with yapping and whimpering spaniels.

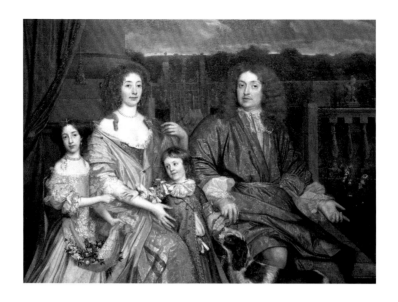

4. Sir Robert Vyner (1636-88) and his family
By John Michael Wright, 1673
Oil on canvas, 144.8 x 195.6cm (57 x 77")
NPG 5568

Sir Robert was an extremely wealthy goldsmith and banker whose constant favours to the newly restored Charles II (he made and presented the regalia used at the coronation in 1661) not only put him on an intimate footing with the King but eventually brought about his financial ruin. This opulent but rather touching family group was painted the year before he became Lord Mayor of London, marking the occasion with one of the most lavish banquets yet seen. It was only natural that he should also use one of Charles's painters, the Scottish-born Michael Wright, from whom he had been instrumental in commissioning other works.

The group includes (from right to left) Vyner's only son, Charles, his wife, Mary, and his step-daughter from his wife's first marriage, Bridget. The portrait is a significant one in British painting and marks a provincial, more realistic and bourgeois development from its Van Dyck predecessors. The little boy's dog with its traditonal symbolism of fidelity and obedience was a standard accessory for the family heir and is used here as a masculine counterpart to the flowers that his sister is holding. Spaniels of all sorts were popular in the seventeenth century and were used for flushing out game, particularly in connection with the gentlemanly sport of falconry. This one, apparently a predecessor of the modern springer spaniel, has an opulent collar and is undoubtedly a status symbol, indicating not only gentlemanly

rank but also a country estate with hunting. The domestic bliss pictured here was not to last for long. Vyner's wife died the following year, in 1683 he was declared bankrupt, the boy Charles died in 1688 and Vyner himself followed two months later, broken-hearted at the death of his only child.

5. Mary of Modena (1658-1718)
By Willem Wissing, 1685
Oil on canvas, 120.7 x 97.8cm (47½ x 38½")
NPG 214

Daughter of the Duke of Modena, the fourteen-year-old Italian princess had already been married to James, Duke of York, by proxy before she came to England in 1673. Earlier and less formal portraits of her by Sir Peter Lely, her brother-in-law Charles II's court painter, significantly often show her with the House of Stuart's favourite dog, a toy spaniel. In 1685, on the accession of James II, she became Queen, and Willem Wissing, a Dutchman and former pupil of the now deceased Lely, undertook the coronation portraits. This is one of a small series of more intimate and informal paintings that were based on the sittings for the coronation portrait and were probably intended as gifts for friends.

The painting positively bristles with conventional symbolism: the rose for the Queen's beauty and virtue, the twining honeysuckle for her constancy and the dog for fidelity. Despite her husband James II's well-documented love of hunting and dogs (he is said to have given the order 'Save the dogs and Colonel Churchill' when the Gloucester with the future Duke of Marlborough on board went down off the coast of Norfolk in 1682), there is no similar evidence for Mary. The little dog seen here, however, seems very identifiable; indeed it is a bitch and looks like an Italian greyhound, perhaps crossed with another breed. Apart from providing an oblique reference to her homeland, it does seem possible that it may have been her own dog, possibly a present from a relative. That it is, nevertheless, also a symbol is made clear in another version of this painting where its place is taken by a cockatoo, to which similar attributes of devotion were ascribed.

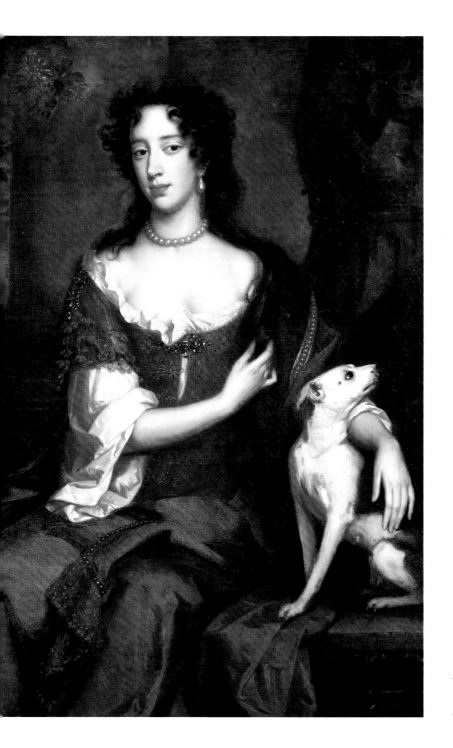

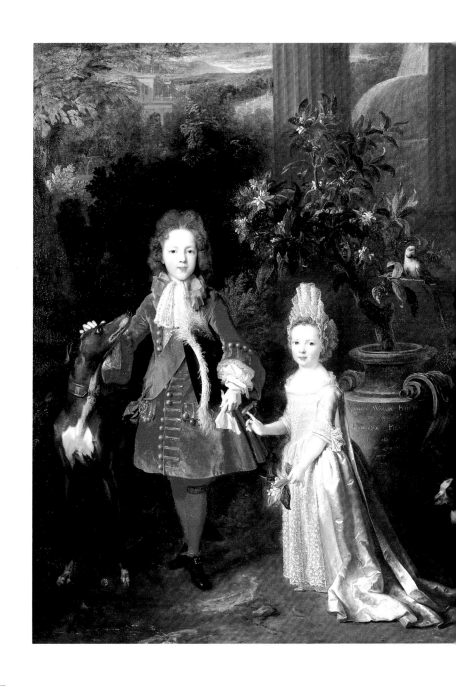

6. Prince James Francis Edward Stuart (1688-1766) and his sister, Louisa Maria Theresa (1692-1712)
By Nicolas de Largillière, 1695
Oil on canvas, 190.5 x 143.5cm (75 x 56½")
NPG 976

Both Charles II and James II had tried to persuade the brilliant French painter Largillière to remain in Britain after he had done several court commissions for them, but with anti-Catholic feeling at its height, he had wisely chosen to return to France. Now, after the bloodless revolution of 1688 and living in exile at St Germain-en-Laye under the protection of Louis XIV, James commissioned this portrait of his children from Largillière as part of his ongoing campaign to re-secure for his family the British throne.

Like the earlier portrait of the baby Charles II [plate 2], this is an unabashed piece of political propaganda, and like the portrait of the children's mother, Mary of Modena [plate 5], it is full of the conventional symbolism of the times. The innocence of the Stuart children in exile is indicated by the orange tree from which the little princess has plucked a sprig of blossom. She points to her brother, the rightful heir and future claimant to the British throne, loyalty to whom is symbolised by the magnificent greyhound standing over a twisting vine of morning glory between its feet, an emblem of constancy. She has her own faithful companions: the little male rose-ringed or ring-necked parakeet, which, like the orange tree and unbroken flow of the fountains behind her, symbolised her virginity and eligibility; and, seen emerging from the shadows behind her train, a small but sadly unidentifiable breed of dog.

The Prince's greyhound was one of the oldest and noblest of hunting dogs, its aristocratic looks, grace and intelligence complementing his

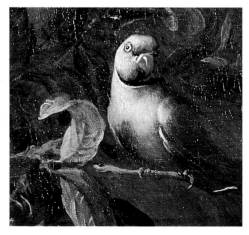

royal status. But unless there is some hidden agenda, the symbolism of the orange tree might seem at best a little careless for it was the House of Orange and Prince William, now King of England, who were responsible for the current plight of the Stuart children.

THE FACE
IN THE
CORNER

35

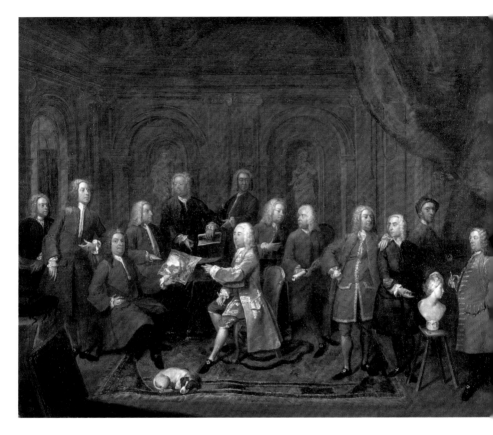

7. A Club of Artists
By Gawen Hamilton, 1734-5
Oil on canvas, 87.6 x 111.5cm (34^1/$_2$ x 43^7/$_8$")
NPG 1384

The man in the dark coat holding a book on the left of this group of early eighteenth-century British artists is the noted engraver and antiquary George Vertue, to whom we owe all we know about this picture and almost everything that is known about its artist, Gawen Hamilton. Vertue described the painting as a 'Conversation of Virtuosis that usually meet at the Kings Armes. New bond Street a noted Tavern'. It includes painters like Michael Dahl and John Wootton, architects like James Gibbs and William Kent and the sculptor Michael Rysbrack. All the figures are named on the painting except the only one in working clothes, Hamilton himself, who is the gaunt figure in a cap on the right behind the bust. Born in Scotland around 1697, he came to London in about 1730 and became Hogarth's chief rival as a painter of small-scale portrait groups like this one, known as

conversation pieces. This probably explains Hogarth's absence from the painting, though in any case the rivalry was short-lived, for Hamilton died young two years later.

There is no evidence for ownership of what looks like a spaniel sleeping peacefully in the foreground, though Hamilton's stylistic trademarks include the almost invariable presence of a dog in the front of his portraits as well as the slightly rucked carpet, which appears to be not quite attached to the floor. It is tempting to suppose that the dog belonged to the ageing Swedish painter Michael Dahl, at whose feet it is sleeping, or even to Hamilton himself, though he stands a long way off. If identifiable at all, a more likely explanation, especially since the grandiose background seems most unlikely to represent a pub of any sort, is that it belonged to the landlord of the King's Armes and as such would have been instantly recognisable not only to everyone in the painting but to all other habitués of that 'noted Tavern'.

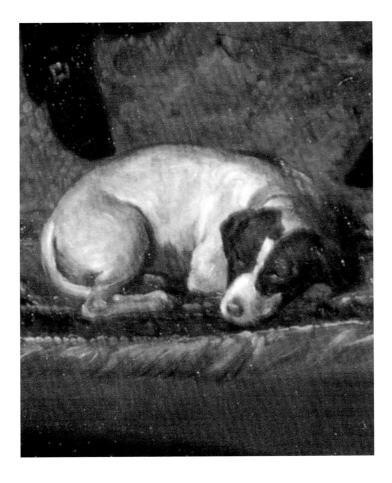

8. Burkat Shudi (1702-73) and his family
By Marcus Tuscher, c.1742
Oil on canvas, 83.4 x 141.5cm (33 x 55½")
NPG 5576

The foremost harpsichord-maker in Britain, Shudi came to Britain from the Swiss canton of Glarus in 1718 and was soon a friend of Handel and a respected member of the musical and German-speaking circles in London. Portraits of his royal patrons, Frederick, Prince of Wales, and Princess Augusta, can be seen hanging on the wall behind and his commercial success was such that he had recently been able to move to this comfortable new town house in Great Pulteney Street, Soho. The painting by a visiting German artist clearly seems intended to show both Schudi's professional and social standing and is an outstanding example of the newly fashionable conversation piece, popular with the new middle classes. His wife, Catherine, also from Glarus, is seen as a woman of leisure reading a newspaper and presiding over tea. His older son, Joshua, is pointing to the source of their well-being, the harpsichord and the business which he will eventually inherit. In fact, his father went into partnership with an apprentice, John Broadwood, and Joshua later became junior partner in Broadwoods, the great piano manufacturers.

The younger son, Burkat junior, being restrained by his mother, is holding what looks like a rusk with which he has been teasing the pretty grey and white tabby, who is mewing in vain for this tasty treat. For centuries cats had been tolerated round the house as the most effective form of rodent control, but since medieval times they had acquired undeserved associations with witchcraft and had been seen as symbols of everything from Satan to lethargy and lust. Such considerations bore little weight in the more rational mood of the eighteenth century and, as here, cats make their appearance in paintings as suitable playthings for children and symbols of civilised domesticity. For a successful professional family like the Shudis with no ambitions to be accepted as country gentlefolk, a cat was a far more suitable pet than a dog for city living.

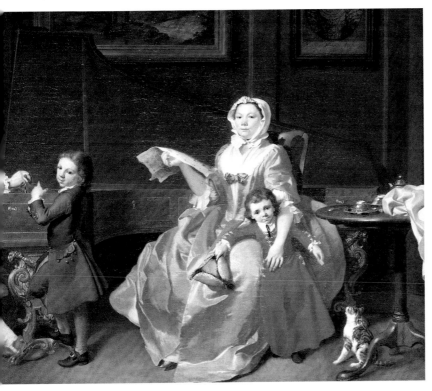

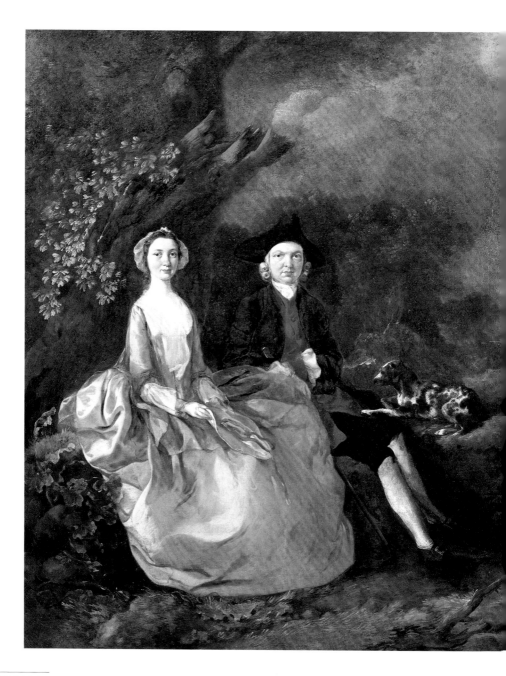

John Joshua Kirby (1716-64) and his wife
By Thomas Gainsborough, *c.*1750
Oil on canvas, 74.3 x 61.6cm (29^1/$_4$ x 24^1/$_4$")
NPG 1421

Gainsborough met the Kirbys after he moved back to Suffolk in 1748, having both completed his apprenticeship and failed to make a living in London. Life in Ipswich was not much more profitable and Gainsborough relied on local professional people for his few portrait commissions and for the even rarer sale of the evocative landscapes, rather Dutch in style, at which he was beginning to excel. Kirby was the author of an early illustrated book on Suffolk and of a well-known book on perspective, but also ran a general painting business with which Gainsborough probably helped him out. This portrait commission may well have cemented what was to become a lifelong friendship, to the extent that in the last weeks of his life Gainsborough gave instructions that he was to be buried next to Kirby in Kew churchyard.

It is possible to deduce from Gainsborough's paintings that he must have loved and owned dogs all his life. His earliest dated painting (1745) is of the magnificent white bull terrier Bumper *and although he only painted about half a dozen such 'portraits', including his own two little dogs* Tristram and Fox *(Tate Gallery), dogs constitute a significant element in many of his major portraits and 'fancy' pictures, especially in later works like* The Morning Walk *[fig. 7]. In the early little self-portrait with his wife and daughter in the National Gallery, painted a few years before the Kirbys, the family's small spaniel drinks from a pool. The Kirbys' dog, looking strangely out of scale and slightly disreputable – a spotty gun dog of some sort – seems designed to introduce a little light and shade into a difficult area of the composition and may have been a later addition. Indeed X-rays reveal several changes of mind during the course of painting, including a large classical monument behind Kirby which was later dispensed with.*

10. William Shenstone (1714-63)
By Edward Alcock, 1760
Oil on canvas, 150.8 x 99.7cm (59³/₈ x 39¹/₄")
NPG 263

'*A large, heavy, fat man, shy and reserved with strangers,*' *William Shenstone was a now seldom-read poet from the Midlands and a bachelor. Of private means, he had inherited the estate of Leasowes near Halesowen from his guardian in 1745 and began what was in effect his life's work, laying out and beautifying the grounds. The Leasowes was to become in the words of his schoolfriend, Dr Johnson, '*a place to be visited by travellers and*

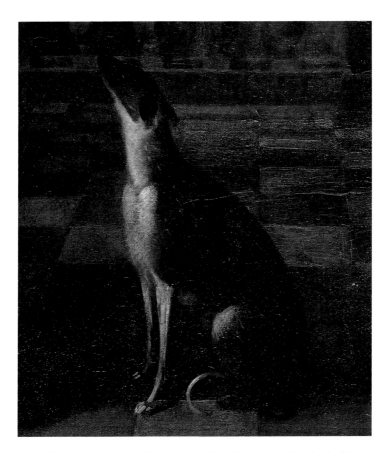

copied by designers', and Shenstone holds an important place in the history of British landscape gardening. Through the arch in the painting can be seen the village of Halesowen and the 'ruinated priory' which he had erected in the grounds.

Shenstone's Letters *include detailed descriptions of his requirements for this portrait, which he had commissioned from a local artist. The relief of the water nymph on the pedestal was to represent the River Stour, 'which in some sort rises at The Leasowes'. The 'scarlet geranium' in the 'antique vase' would also reflect his interests, though it had to be supplied by a friend. 'The dog on the other side is my faithful Lucy, which you perhaps remember,' Shenstone says in a letter to his lifelong friend, the poet Richard Graves. In contrast to the outdoor pursuits usually implied by eighteenth-century portraits of one man and his dog, the classical allusions and the look of mute adoration on the face of the little greyhound imply a closer form of companionship. Lucy may well have outlived her master, for Shenstone died three years later.*

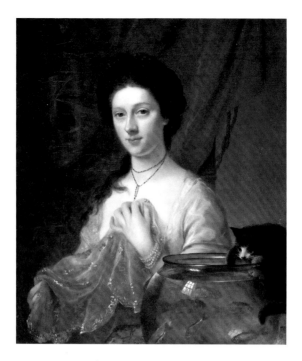

11. Catherine 'Kitty' Fisher (d.1767)
By Nathaniel Hone, 1765
Oil on canvas, 74.9 x 62.2cm (29½ x 24½")
NPG 2354

When this portrait was exhibited anonymously at the Society of Arts in 1765, the art critic of the newspaper The Public Advertiser *observed: 'This is a portrait of a Lady* whose charms are well known to the town. *The Painter has ingeniously attempted to acquaint us with her name by a rebus upon Canvass.' In fact, the artist's punning clue, the 'rebus' of the kitten fishing, can scarcely have been necessary, for Kitty Fisher was not only one of the most celebrated beauties in the London of the late 1750s and early 1760s but was also a notorious courtesan.*

The artist, the Dublin-born Nathaniel Hone, was not otherwise known for his wit, but the portrait bears all the hallmarks of the considerable charm he brought in particular to portraits of children, whom he often pictured with a favourite pet. The mischievous black and white kitten was in more ways than one a suitable metaphor for his subject here, and the image is laden with symbolism. With a certain naïve innocence, Kitty had published a defence of her character in 1759, and the reflection in the goldfish bowl of the crowd of people watching through the window is a vivid comment on the sort of invasion of privacy from the media with which we are all

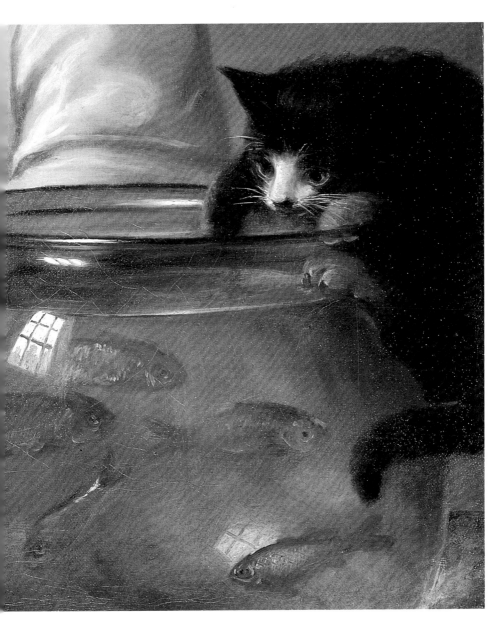

too familiar today. The goldfish in themselves are unusual, possibly even making their first appearance in a European painting. They are believed to have been first introduced into Britain from China some seventy years before the date of this picture and were probably shipped in large glass bowls similar to this one.

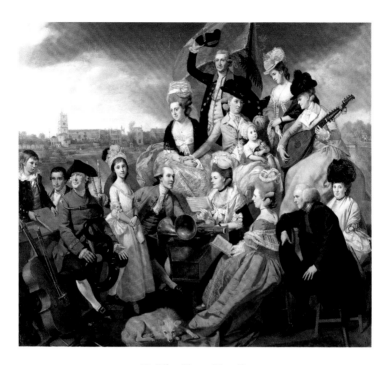

12. The Sharp Family
By Johann Zoffany, 1781
Oil on canvas, 115.5 x 125.7cm (45$^1/_2$ x 49$^1/_2$")
On loan from the Trustees of the Lloyd-Baker Settled Estates

This tour de force *of a conversation piece was painted for William Sharp, the man at the back of the barge waving his hat, who was surgeon to George III. It depicts one of the regular family concerts given by this musical family which in the summer were held in a barge on the Thames (Fulham Church can be seen in the background), and it remains one of the most vivid pictures of eighteenth-century family life. William's wife sits in front of him holding their two-year-old daughter Mary, who, being too young to participate, has in the best traditions of eighteenth-century child portraiture been given a kitten to hold. Sharp's brother Grenville, sitting behind the spinet and French horns, was a well-known philanthropist and abolitionist. Their father, Thomas, in the bottom right-hand corner, was Archdeacon of Northumberland.*

Zoffany, who was responsible for this feat of organisation and detail (there are eight musical instruments depicted) was born in Germany and, after a creditable start to his career painting late baroque decorations and religious pieces, decided to try his fortune in England. He arrived in London in 1760 and by 1762 had been taken up by the great actor David

Garrick, for whom he painted several family groups and more especially a number of scenes from Garrick's plays. Zoffany was in a sense able to pick up where Hogarth, who died in 1764, left off, and he took the conversation piece to new heights of sophistication. More coincidentally, like Hogarth with his pugs, he also introduced his own dog, a white German spitz called Poma, into his portraits. Sharp family tradition had it that the dog became so attached to them that it had to be included in the painting. Exactly the same rather tender view of the recumbent Poma, however, appeared again in Zoffany's portrait of John Wilkes and his daughter [fig. 6] the following year. It seems likely that Zoffany was inclined to re-use a good motif when he found one, especially if, as seems apparent with the Wilkeses, he found his sitters rather unsympathetic. A white spitz standing on its hind legs appears in at least two Zoffany conversation pieces from the late 1760s, though it seems more likely to be one of Poma's predecessors.

13. Robert Bakewell (1725-95)
By John Boultbee, c.1788–90
Oil on canvas, 70.3 x 90.5cm (27$^1/_2$ x 35$^1/_2$")
NPG 5949

Described rather quaintly in the Dictionary of National Biography *as a grazier, Bakewell was in fact a pioneer of agricultural economics and his stock-breeding programmes paved the way for today's specialised and intensive farming techniques. Portrayed here as the bachelor yeoman farmer that he was, and working from his country seat at Dishley Grange in Leicestershire, he experimented with his local Longhorn cattle to produce small-boned animals producing the maximum amount of meat and fat in the shortest time to feed and provide tallow candles for the rapidly growing and industrialised population. The results of this programme were the*

ridiculously small-headed and cylindrical-bodied cattle familiar to us from early nineteenth-century paintings. Some of Bakewell's Longhorn cattle can be seen grazing in the field behind.

The artist John Boultbee was also a Leicestershire man whose paintings at their best can be mistaken for those by Stubbs. He was quickly adopted by Bakewell to portray (and thus advertise through subsequent prints) his latest prize cattle. This portrait seems actually to have been commissioned by an associate of Bakewell's, John Fowler, and exists in four versions. That Boultbee was no Stubbs can be seen not only in the portrait's charming naïvety but also in his problems with the horse's anatomy. Changes to the position of the horse's legs are visible in at least three of the different versions. This version is apparently the only one to show the little dog, which is probably some sort of local terrier. Gazing slightly reproachfully at its master as if asking to be given a lift instead of having to run round after the horse, it adds a humane and narrative touch to the portrait of a man who, despite his calling and his grisly museum of pickled joints and skeletons, was known for his concern for his animals' welfare.

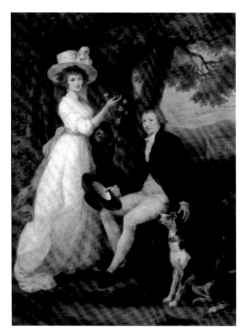

14. Thomas Jenkins (1722-98) with his niece Anna Maria
By Angelica Kauffmann, 1790
Oil on canvas, 129.5 x 94.6cm
(51 x 37¹/₄")
NPG 5044

Thomas Jenkins went to Rome in the early 1760s to study painting, but finding he could make a better living from dealing in the wealth of antiquities currently being excavated, remained there for the rest of his life and added banking to his accomplishments. Despite an unsavoury reputation for manufacturing and improving upon some of his antiquities, and taking hefty commissions for the sale of visiting artists' work, he was genuinely helpful to a number of artists, obtaining access for them to copy works in private collections and acting as their agent. He had handled the Swiss-born artist Angelica Kauffmann's financial affairs since she had arrived to settle in Rome with her new husband in 1782. A genuinely international figure, she had attracted the notice of the great classical scholar Winckelmann with her dainty neo-classical paintings in Rome twenty years earlier, before moving to England in 1766. There she became a protegée of Reynolds, a founder member of the Royal Academy, and was employed by the Adam brothers to decorate rooms and ceilings.

Kauffmann was obviously content with Jenkins's services, for she gave him as a gift this portrait of himself with the niece who had recently arrived to live with him in Rome. In the Memorandum *of her pictures, she scrupulously noted: 'For Mr. Thomas Jenkins, English … the portrait of the above and of his niece Anna Maria, likewise the portrait of the pet dog.' Nothing else is known of the pet dog, though its specific inclusion in the portrait, Jenkins's protective hand and the dog's look of adoration in return make it clear that this was a domestic rather than a sporting relationship. It looks a bit like a collie, but since Jenkins had been in Rome for nearly thirty years is more likely to have been some sort of native Italian sheep dog. In the sylvan background, Kauffmann has included a somewhat incongruous view of the Colosseum, little suspecting perhaps that it was from a reliable contact there that Jenkins obtained many of his fake antiquities.*

15. Sir Francis Chantrey (1781-1841)
Self-portrait, *c*.1805
Pencil and wash on off-white paper,
13.6 x 14.3cm
(5³/₈ x 5⁵/₈")
NPG 2103A

Though destined to become one of the most famous sculptors of his age, Chantrey was the son of a tenant farmer near Sheffield and had a modest reputation as a painter there before coming to London in 1802. He did not entirely abandon painting until 1808, and married his cousin from Yorkshire at about the same time. This drawing was sent to some London friends soon after his arrival, and apart from being ironically inscribed in ink 'Sketch from nature', is also inscribed in pencil '(a bachelor)'. An accompanying note explains that the drawing was sent to explain that he could not visit his friends as usual since he was confined to his lodgings with mumps. Beneath the row of medicine bottles on the mantelpiece is the name of his doctor, Mr Merreyman.

While the attendant dogs and mother cat and kitten obviously serve to add poignancy to Chantrey's current predicament (and may of course have belonged to his landlady), Chantrey is known to have been very fond of animals. A pointer called Hector is recorded – though probably of later vintage than the small supplicant hound in the drawing – and, immortalised in paint, the Dandie Dinmont terrier called Mustard that was given to Chantrey by Sir Walter Scott in 1825 in return for his bust of the famous novelist. Scott had of course more or less invented Dandie Dinmonts in his novel Guy Mannering *(1815), and in 1836 Chantrey commissioned from his friend Sir Edwin Landseer a portrait of Mustard sitting by a copy of the bust in a corner of his studio and keeping one of the sculptor's cats under the table at bay. Mustard had by then, alas, wrote Chantrey's biographer George Jones, '... increased his bulk, and he became a striking example of the effects of luxury and repletion, yet his obesity and indolence did not diminish his devotion to his master...'.*

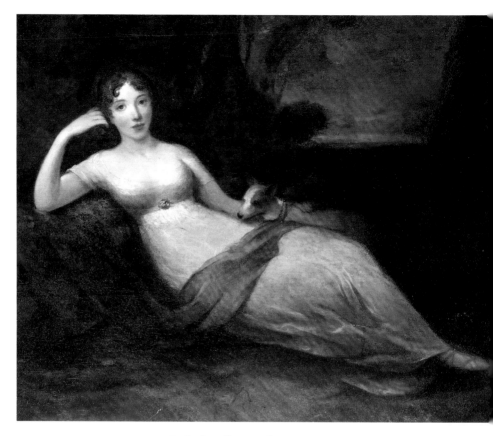

16. Lady Caroline Lamb (1785-1828)
By Eliza H. Trotter, c.1810
Oil on canvas, 114.9 x 140.3cm (45¼ x 55¼")
NPG 3312

Lady Caroline Lamb's famous note in her diary in 1812 after meeting Byron for the first time – 'mad, bad and dangerous to know' – was not only perspicacious but might equally well have been applied to herself. Married to William Lamb, the future Lord Melbourne and Prime Minister to Queen Victoria, she nevertheless became Byron's lover for several months before, finding her too much to handle, he terminated the relationship. She pursued him obsessively, becoming increasingly eccentric and even violent, especially so after the poet's death in 1824, when her long-suffering husband finally decided that they must separate. She had written several highly romantic novels and some conventional verse, and after further romantic entanglements with younger men such as the novelist Bulwer Lytton, died in London at the age of forty-two.

The circumstances of this rather amateurish but charming portrait by Eliza Trotter, the daughter of an Irish portrait painter, are not recorded, but the fact that it belonged to Caroline and the presence of the miniature bull terrier gives a strong clue to its extraordinary origins in the scandalous world of Regency society. Dressed in the provocative 'see-through' neo-classical dress of the time, Caroline had allowed the portrait to be exhibited simply as Portrait of a Young Lady at the Royal Academy in 1811. To anyone who knew her well, its identity would of course have been obvious, and like a later well-known portrait of her as a page by Thomas Phillips, it seems to have carried a coded message for those who could read it. The previous year, Caroline had begun her first extra-marital affair with a certain Sir Godfrey Webster, who is recorded as giving her two presents, a bracelet and a dog. Both presents appear to be shown in the painting: the little dog can be seen to be wearing not only its own collar, but also an apparently valuable bracelet – presumably Sir Godfrey's – of set and linked gemstones with a clasp.

This parading in public of a scandalous affair must have been extremely distressing to her family and the portrait may well have been one of the factors which caused Lady Melbourne, her mother-in-law, to write to her: 'Had you been sincere in your promises of amendment, or wished to make any return to William [her husband] for his kindness, you would have discarded and driven from your presence any persons or things which could remind you of the unworthy object [her lover] for whose sake you had run such risks and exposed yourself so much. But on the contrary you seem to delight in everything that recalls him to you....' In fact, the dog, whose name seems to have been Phyllis, eventually caused Caroline to repent after it had bitten her only and tragically retarded son, Augustus. No reprisals against Phyllis appear to have been taken, however, and Caroline was soon writing to her husband from Brocket Hall, their country house: 'Plunger [her husband's dog?] ran away from me yesterday, and Francis found him parading at the top of the park with some stray poultry. I would not bring my pretty Phyllis, as you wished not.' If Phyllis were indeed Sir Godfrey's gift to his wife, one can appreciate Lamb's reluctance to be reminded of the fact. He may well have recalled an entry he had made in his common-place book in 1809: 'Before I was married, whenever I saw the children and the dogs allowed... to be troublesome in a family, I used to lay it all to the fault of the master of it, who might at once put a stop to it if he pleased. Since I have married, I find that this was a very rash and premature judgement.'

17. Sir Francis Burdett 1770-1844
By Sir William Ross, *c.*1840
Watercolour on ivory (miniature), 39.4 x 34.3cm (15^1/$_2$ x 13^1/$_2$")
NPG 2056

This charming oversize miniature of an elderly country gentleman dressed for riding and sitting in his library with his dog contains perhaps only one clue to the fact that he was one of the most radical and outspoken politicians of his time: the bust, dominating the room, of his mentor, the famous political agitator of a previous generation, John Horne Tooke. A fearless advocate of free speech and the reform of the House of Commons, Burdett was a constant thorn in the side of the government and was twice imprisoned. By the time of this portrait, and with reform achieved, he was siding with the Tories, had more or less retired from active politics and was devoted to fox hunting.

Pursuing his humanitarian interests, Burdett was one of the sponsors of the Martin Act of 1822, the first piece of legislation for protecting animals. He had married into the Coutts banking family and his love of animals was amply inherited by his daughter, Baroness Angela Burdett-Coutts, the philanthropist and famous heiress to the banking fortune. She instituted countless schemes for improvements both in animal welfare and farming, became President of the RSPCA and erected the statue to the legendary Skye terrier Greyfriars Bobby in Edinburgh in 1872. She kept numerous pets at her house in Highgate, including llamas on the front lawn, a famous cockatoo called Cocky and her favourite dog, a small Manchester terrier called Fan, whose biography she wrote. Her father's dog is less well documented and being, unusually, seen from behind is less easy to identify. It certainly seems a suitable companion for hunting, possibly an early form of Airedale terrier, and is well provided for by the unique and elegant water bowl, prophetic perhaps of the numerous drinking fountains for men and animals alike that his daughter would erect around the country.

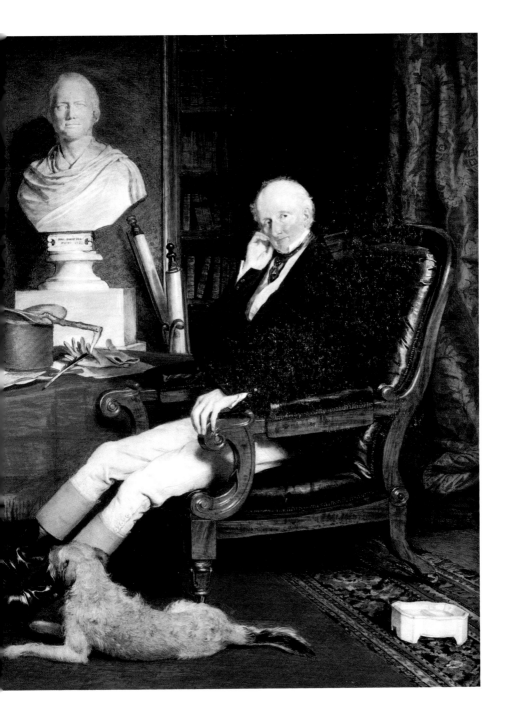

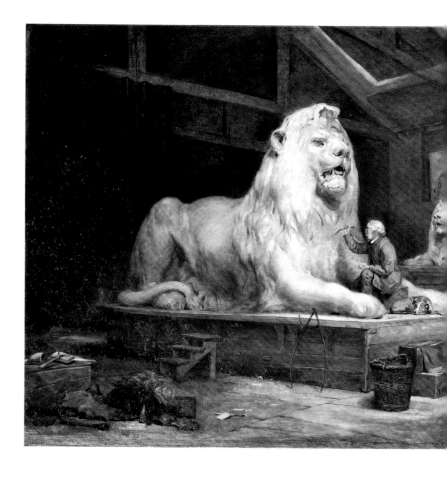

18. Sir Edwin Landseer (1802-73)
By John Ballantyne, c.1865
Oil on canvas, 80 x 113cm (31½ x 44½")
NPG 835

The most famous British artist of his day and certainly the greatest animal painter of the nineteenth century, Landseer was more or less obliged against his better judgement to undertake the monumental task of modelling the lions for the base of Nelson's Column in Trafalgar Square. He was occupied with the project on and off from 1858 to 1866 and there is little doubt that it was a major contributory factor to the ill health that clouded the last ten years of his life. After a barrage of sniping in the press about the commission being given to a painter and the lack of progress, he opened his studio in 1863 to a select gathering to view the initial six-foot model on which he had been working. Ballantyne's painting, one of a series of six famous artists in

their studios, was probably based on photographs taken around this time and shows Landseer at work on the final twenty-foot model in the borrowed studio of the sculptor Baron Marochetti. Marochetti was eventually responsible for casting the four bronzes, which were finally put in place in January 1867.

Landseer owned a number of dogs all his life and acute observation of his own pets – combined with a strong vein of sentiment and an immaculate technique – undoubtedly helped to make him the greatest and most successful painter of dogs of all time. As such, he was one of the very small number of artists whose work appealed to Queen Victoria, and she and Prince Albert commissioned a large number of paintings of their own extensive collection of dogs. The brown dog on the platform here, patiently attending her master, is almost certainly Landseer's faithful collie Lassie, who was known to have been his constant companion in the studio at this time. Her appearance agrees well with the one in a famous self-portrait, also of 1865, called The Connoisseurs, which Landseer later presented to Edward, Prince of Wales.

19. Charles Reade (1814-84)
Attributed to Charles Mercier, c.1870
Oil on canvas, 109.9 x 140.3cm (43¼ x 55¼")
NPG 2281

Author of The Cloister and the Hearth *(1861) and* It Is Never Too
Late to Mend *(1856), Reade was one of the most popular of all Victorian
novelists and dramatists, though his work has not stood the test of time. With
an inclination for melodrama, he was a sort of English Victor Hugo, though
his social concerns led him to associate himself with Zola, whose*
L'Assomoir *he adapted for the stage under the uncompromising title
of* Drink *(1879). Given the striking respectability of this most Victorian
of interiors, his private life has long been the subject of speculation
and for nearly thirty years he lived with an actress, then described as his
housekeeper and hostess, Mrs Laura Seymour.*

*Relatives recalled that the room depicted in this portrait was in his house
at 2 Albert Terrace, Knightsbridge, and that 'in a large room on the ground
floor, looking into Hyde Park, which he called his workshop, he laboured
until the end of his life for at least one hour every afternoon at ponderous
ledgers, which he filled with notes or cuttings from books or newspapers on*

topics that appealed to his interest.' There is little doubt that the painting depicts one of these afternoons, and his cat with two kittens dozes lazily on one of the many ledgers scattered round the room. Reade was said to have had a whole menagerie, but his niece remembered that the white German spitz waiting patiently to be taken out into the park belonged to Mrs Seymour and was called Puff. One of the portraits on the walls, presumably the one on the right, was of Mrs Seymour. Reade never recovered from her death in 1879 and was buried beside her in Willesden five years later.

20. Sir Daniel Gooch (1816-89)
By Sir Francis Grant, 1872
Oil on canvas, 142.2 x 111.8cm (56 x 44")
NPG 5080

As a boy in Northumberland, Gooch had sat on George Stephenson's knee and acquired a life-long love of steam engines. In 1837, at the age of 21, he was appointed locomotive superintendent of the Great Western Railway and worked with his friend Isambard Kingdom Brunel on designing and improving locomotives for Brunel's broad-gauge track and laying the foundations for the modern railway system. He received his barontecy in 1866 for inaugurating the Trans-Atlantic Telegraph and had sent and received the first cable messages to America earlier that year. Returning to the Great Western in 1865, he rescued it from bankruptcy and was subsequently instrumental in the construction of the Severn and Mersey tunnels. The only clue to all these achievements in Sir Francis Grant's urbane portrait is the pair of dividers which Gooch holds in his hand. Instead, he shows him as the country gentleman and MP that he had become, sitting in bourgeois splendour next to a view suggestive of his native Northumberland moors, with his large black retriever by his side.

Before he became a painter, Grant had studied for the law but was also a keen fox-hunting enthusiast. He painted one of the last portraits of Sir Walter Scott, showing the novelist with his two deerhounds in 1831 (the portrait is in the Scottish National Portrait Gallery) and much of his mature work is of hunting groups or equestrian portraits. As such he enjoyed a friendly rivalry with Sir Edwin Landseer and became President of the Royal Academy when Landseer declined the post in 1866. Grant's painting of Gooch's panting black retriever is a tour de force *not unworthy of Landseer, though totally without the latter's sentimentality. Retrievers were a relatively new group, originally developed in Britain specifically as gun dogs from crossings principally between Newfoundlands and labradors, though this long-haired black variety does not correspond to any of today's breed standards. It may have been a forerunner of the flat-coated retriever.*

21. John Brown (1826-83)
By Hills and Saunders, about 1880
Modern print from original negative
NPG x35278

Appointed by Prince Albert in 1849, John Brown became Queen Victoria's personal servant in Scotland, but by 1864 he had been brought south to Osborne and before long had become totally indispensable to her. Hated by most of the Royal Family and despised by the court for his coarseness and rudeness, his privileged position was not without its stresses and he took to heavy drinking. Despite looking hale and hearty in this photograph, he died prematurely a few years later.

This appears to have been taken below the south terrace at Windsor and shows Brown entrusted with the Queen's favourite dogs of the period. The smooth fox terrier whom Brown seems at pains to keep under control with his stick appears in a commemorative portrait by C. Burton Barber which Victoria commissioned a few months after Brown's death, and is identified as Wat. The border collie with the striking white T-mark on his chest, seated on the steps below, is one of a dynasty of at least four collies called Noble and also appears in the Barber painting. From other paintings by Barber in the Royal Collection, it is possible to conjecture with some certainty that the collie in Brown's embrace was called Fern and the little smooth-coated dachshund, Waldmann. Waldmann was the second of Victoria's dachshunds of that name, many of them gifts from relatives in Germany. She had acquired him in Baden in 1872, and when he died in February 1881 she wrote in her diary: 'Such a dear kind little dog – & kept all the others in order.'

22. Alan, 3rd Baron Gardner (1810-83)
By Sir Leslie Ward ('Spy'), 1883
Watercolour, 30.5 x 18.1cm (12 x 17¹/₈")
NPG 3287

The title of this cartoon when published in the popular magazine Vanity Fair *was 'Fox Hunting', rather surprisingly perhaps in view of the affable old gentleman depicted and his grossly overweight collie. Lord Gardner had in his younger days, however, been a member of the most fashionable circles, a friend of Count D'Orsay and Lady Blessington, and a legendary huntsman. Now, as* Vanity Fair *notes, he had become a good shot and taken up salmon fishing. Many of Sir Leslie Ward's drawings were, unlike most caricatures, done from actual sittings with his subjects, and the portraits of both master and dog here have an authentic feel to them. Lord Gardner died soon after the publication of this drawing and one might speculate that the ageing collie was not long in following him. Collies had become very fashionable since receiving the royal seal of approval and Queen Victoria owned a number of them in her widowhood. In the 1870s, her favourite collie, Sharp, had had his portrait exhibited at the Royal Academy.*

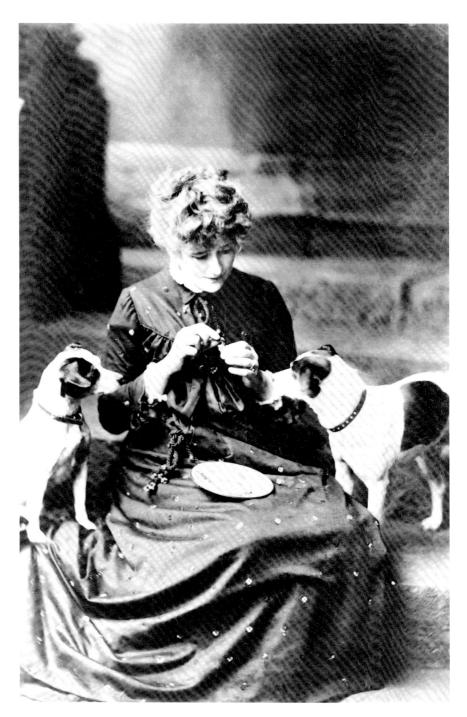

23. Ellen Terry (1847-1928)
By an unknown photographer, c.1885–90
Bromide postcard print, 13.2 x 8.7cm (5 x 3½")
NPG x17049

Writing in 1914 from Australia to her great friend, the painter, writer and dog owner W. Graham Robertson, on one of the punishing lecture tours she undertook in later life, the great actress remembered some of the many dogs she had known: 'I cd think of nothing but Dogs for a long while – they were much easier to think of than people – & I babbled of Snob – Winkie – Charley – Fussy – Drummy & Bossy as well of all my later *Ducks – (Dogs –).' Fussie was the fox terrier she had acquired from the famous jockey Fred Archer in the mid-1880s and, since he was the first fox terrier she had owned, may reasonably be assumed to be one of the two being tempted with titbits by his mistress, apparently on a stage set. The other is probably Drummy or Bossy.*

It was in 1878 that Ellen Terry finally went into regular partnership with her great opposite number, Henry Irving, at the Lyceum Theatre and went on to create some of her most memorable roles. The relationship with Irving was a close though informal one and she and Fussie accompanied Irving on all his American tours between 1883 and 1897. Gradually however, as Ellen Terry remembered in her autobiography, Fussie 'had his affections alienated by a course of chops, tomatoes, strawberries, "ladies' fingers" soaked in champagne and a beautiful fur rug of his very own presented by the Baroness Burdett-Coutts!', and his ownership was officially transferred to Irving. As Irving's dog, Fussie's exploits and requirements became legendary. He had his own chair in Irving's dressing-room, made (unscheduled) appearances on stage round the world, found his way from Southampton back to the Lyceum after missing the boat to America for the 1888 tour, and after missing the train from New York was discovered by the station master trotting dutifully after it down the line to California. Fussie met his end in 1897 after falling through a trap door on the stage in Manchester. 'Henry was not told until the end of the play…We drove [to the hotel] and found him there eating his supper with the poor dead Fussie, who would never eat supper any more, curled up in his rug on the sofa… He is buried in the dogs' cemetery, Hyde Park.'

24. Dame Ethel Smyth
(1858-1944) with Marco
By an unknown photographer, c.1891
Platinum print, 14.2 x 10.6cm (5^1/$_2$ x 4")
NPG x13395

As a pioneer campaigner for women's rights and the first British woman composer to achieve international renown, Dame Ethel's least known work may well be Inordinate(?) Affection, an autobiographical account of her dogs which she published in 1936, just after the loss of Pan IV, one of a series of Old English sheep dogs all called Pan.

'The incomparable Marco', as she calls him, was her first dog. A St Bernard cross, he had been acquired by a friend from a Viennese washerwoman who had, like others of her trade, intended to use him to pull the little cart with which she collected the washing. As a student composer of songs and chamber music, Ethel had been living and studying in Leipzig since 1877 and after the painful break-up of a passionate friendship with the wife of her first teacher in 1885, was clearly ready for a different sort of relationship. Indeed the succession of large dogs which dominated her later life seems to have played a part in fulfilling the emotional needs that her exuberant and friendly nature demanded.

The relationship with Marco, whom she took back to Leipzig in 1887, was clearly a marriage made in heaven. Before she finally returned to England with him in 1889, he had, as she relates with transparent relish, burst in on a rehearsal with Brahms and almost knocked him off the piano stool, demolished a hotel room during a trip to the Paris Exhibition, and terrified Tchaikovsky, who nevertheless added a cautious PS to a letter of 11 April, 1889: 'J'espère que votre cher chien va bien'. Within a year her first orchestral music had been performed and in 1893 the Mass in D, one of her most important works, was given its première. Professionally and emotionally she was out of what she later described as her 'desert'.

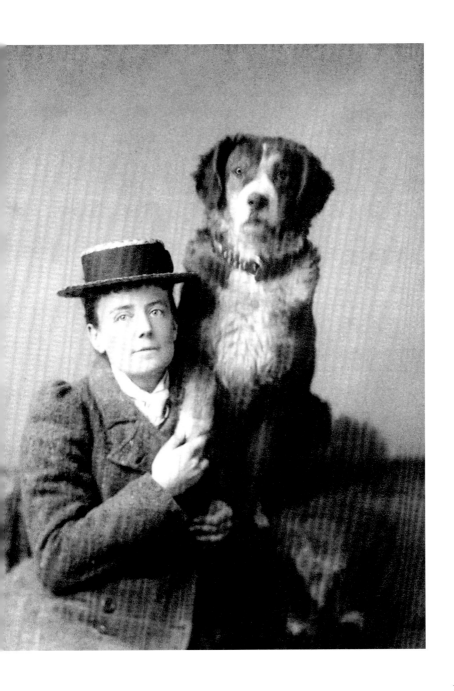

67

25. Queen Alexandra (1844-1925)
By Sir Luke Fildes, 1894 (replica 1920)
Oil on canvas, 128.3 x 102.9cm (50^1/$_2$ x 40^1/$_2$")
NPG 1889

The daughter of King Christian IX of Denmark, Alexandra married the Prince of Wales, the future Edward VII, in 1863 and made herself widely loved both for her charitable work and for her beauty. Her work for hospitals is still commemorated annually in Alexandra 'Rose' day. When the Gallery approached her son King George V in 1920 to inquire about the possibility of obtaining a portrait of her, he commissioned the artist Sir Luke Fildes to produce this replica of a portrait originally painted to commemorate his marriage to Princess Mary in 1894.

Although Alexandra had grown up with dogs in Denmark, it must have amazed her to see the huge number and range of dogs kept by her mother-in-law, Queen Victoria, in the royal kennels at Windsor. She continued the tradition with enthusiasm and like Victoria benefited from diplomatic gifts of the latest breeds from abroad. The first Pekinese, originally brought to Victoria in 1861, remained favourites all Alexandra's life. One called Little Billie slept at the foot of her bed and is said to have accompanied her to Russia. After the opening up of Japan to foreigners in the 1870s and 1880s, other breeds began to appear, including the Japanese Chin pictured here. Alexandra owned a number of these, though the date of the portrait and the dog's markings suggest that this is probably Punch, who was a special favourite and appears in several photographs with her. It is difficult to imagine that he was not also chosen to go with her dress.

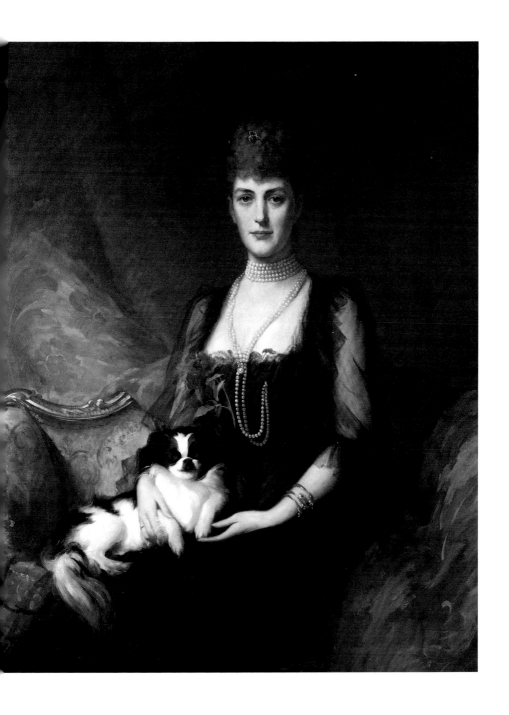

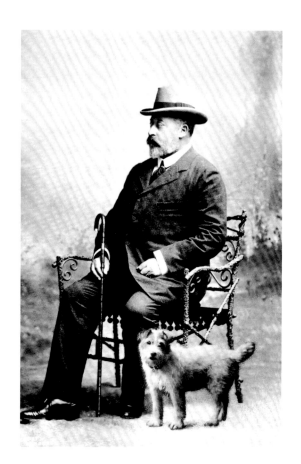

26. Edward VII (1841-1910)
By Thomas Heinrich Voigt, *c.*1900
Sepia glossy postcard print, 12.5 x 8.1cm (5 x 3")
NPG x39946

Though better remembered for his beautiful Queen and for a number of famous mistresses, one of the most constant and faithful companions of Edward VII's last years seems to have been the small terrier called Caesar. As can be seen from the numerous retouchings round the dog, the photograph is in fact a fake and Caesar, who wore a collar inscribed 'I am Caesar, the King's dog', was reunited with his master and the result issued as a postcard by an enterprising German photographer after the King's death in 1910.

Caesar, described unconvincingly as a long-haired fox terrier (though one of his parents may have answered to that description), had been the King's constant companion in private life for seven years or so but shot to fame at the King's funeral when he was delegated by Queen Alexandra to

follow the coffin in the procession from Westminster Hall on its way to Windsor. An already emotional nation was moved to tears at the sight of the somewhat disreputable-looking terrier trotting behind the gun-carriage, and entrepreneurs were quick to produce suitable souvenirs like this postcard. One quick-witted publisher even brought out a memoir entitled Where's Master?. According to Lord Esher, who went to tea at Buckingham Palace several weeks later, 'Caesar... won't go near the Queen – and waits all day for his master, wandering about the house.' There was indeed little love lost between Caesar and the Queen, who preferred rather better bred dogs. 'Horrid little dog,' she exclaimed to Margot Asquith, whose husband had told her that he had seen Caesar after the King's death lying at his feet: 'For warmth, my dear,' explained the Queen.

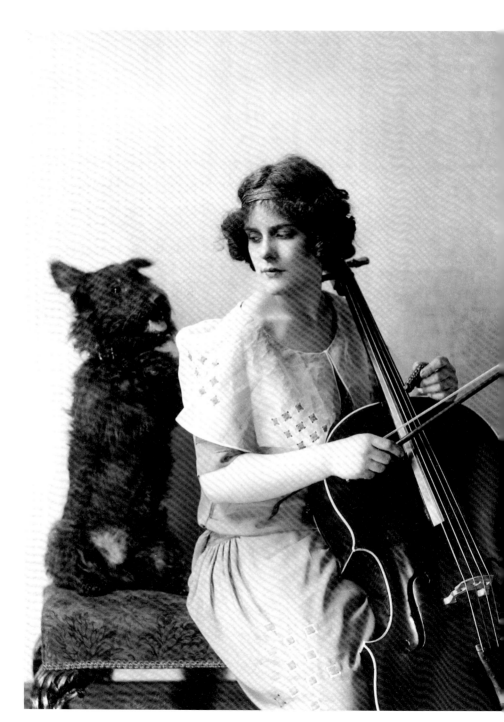

27. Beatrice Harrison (1892-1965)
By Dorothy Wilding, 1923
Modern bromide print from original negative
NPG x36710

Even considering the extraordinary proliferation of musical siblings in the early part of the century (the D'Aranyi sisters for example), the four Harrison sisters remain quite exceptional. Beatrice was the outstanding British cellist of her generation, often ranked at the time with Casals. Her older sister, Margaret, was a pianist and violinist, the third sister, May, an exceptional violinist and the youngest, Monica, a singer. Beatrice was on intimate terms both with the Royal Family and with leading composers of the day: Bax and Delius wrote cello concertos for her, and Delius his double concerto for her and for May, who were both also celebrated for their interpretation of the Brahms.

In 1923, shortly before this photograph was taken, the family moved to a house near Oxted in Surrey where Beatrice discovered that there were nightingales in the wood at the bottom of the garden and, more excitingly, that she could accompany them on her cello while they sang. The BBC agreed to attempt an outside broadcast, which was finally successful in May 1924 and caused a sensation. In her autobiography, Beatrice devotes more attention to the nightingales than to her dogs, of which she admits to sixteen in the household, along with assorted reptiles, birds, seven cats, a parrot and a donkey. Described somewhat coyly as 'a pupil' when the photo was published in Tatler, *this nameless black Scottie was obviously a special favourite and appears with her in another photo of about this time taken in the garden. After the war, when her concert career was in decline, Beatrice joined her sister Margaret and a friend in breeding Irish wolfhounds.*

28. Anna Pavlova (1882-1931) with Jack
By Lafayette, 1927
Modern bromide print from original glass negative
NPG x49320

A legend in her own lifetime, the famous Russian dancer was prima
ballerina at the Imperial Ballet in St Petersburg by the age of twenty-five,
spent one season with Diaghilev's Ballets Russes in 1909 and then created
her own company, touring the world until she finally burnt herself out

and died before reaching fifty. If she had a home anywhere, it was at Ivy House in Golders Green, London, a palatial villa with a park-sized garden where she returned every year for a brief resting period and where she kept her theatrical costumes and music library in the cellar. There too she created a spectacular garden and kept a collection of her favourite birds. There were dogs as well, notably a Boston terrier named Poppy and a French bulldog named Duke, but according to her husband's biography, these all fell victim to quarantine regulations on her tours and ended up being parked on friends in varous parts of the world.

Pavlova's most famous role was 'The Dying Swan', originally created for her by Fokine in 1905, and in which she was painted by Sir John Lavery for the once well-known picture in the Tate Gallery. It was perhaps inevitable that an admirer would present her with a pair of mute swans and Jack and his mate arrived soon after she had acquired Ivy House with its specially enlarged lake in 1913. Jack appears to have behaved like any ordinary swan – 'a splendid big bird, but rather bad-tempered and unapproachable' – until after Pavlova's return to Britain in 1918, when an unidentified swan expert offered to tame it. 'The results…soon showed themselves. Jack became quite tame and his family increased rapidly from two to eight…[Pavlova] would take him on her knees and twine his neck round hers and Jack would take it all without the slightest protest.' Jack must have been at least fifteen, a good age for a swan, when this extraordinary photograph was taken, and one cannot help thinking it gives very real substance to the Leda myth. He was succeeded by his son, also named Jack, who outlived their remarkable mistress.

29. Elinor Glyn (1864-1943)
By Paul Tanqueray, 1931
Bromide print, 23.2 x 14.1cm (9 x 5^1/$_2$")
NPG x16448

The famous, one might say notorious, novelist is better remembered for her invention of the 'It' factor and for the possibility of sinning with her on a tiger skin than for her novels. Though it portrays her past her first youth, Paul Tanqueray's memorable image conveys something of her intense and passionate nature, which is helpfully underlined by the two cats. In fact, by the time of her demise, she had five tiger skins, three of them named after lovers, though the cats were not acquired until she finally settled back in England in 1929 after seven years in America as a Hollywood scriptwriter for silent films. Even so, at the age of sixty-five she formed her own film production company in London, though she was obliged to abandon it the following year after the first film received devastating reviews and the second remained unreleased.

The cats were named Candide and Zadig as a tribute to Voltaire, whom Elinor had apparently cherished after finding a copy of his Zadig *as a little girl in her hated step-father's library in Jersey. Her grandson and biographer, Anthony Glyn, remembered them both (despite the visual evidence) as marmalade-coloured, 'beautiful proud independent creatures of enormous character and "it", in many ways very like their mistress… they became as much a feature of her life as her tigers.' Indeed, in 1939 Elinor caused a sensation by speaking at a literary lunch at the Dorchester while wearing Candide round her neck as a stole. The cat apparently behaved impeccably.*

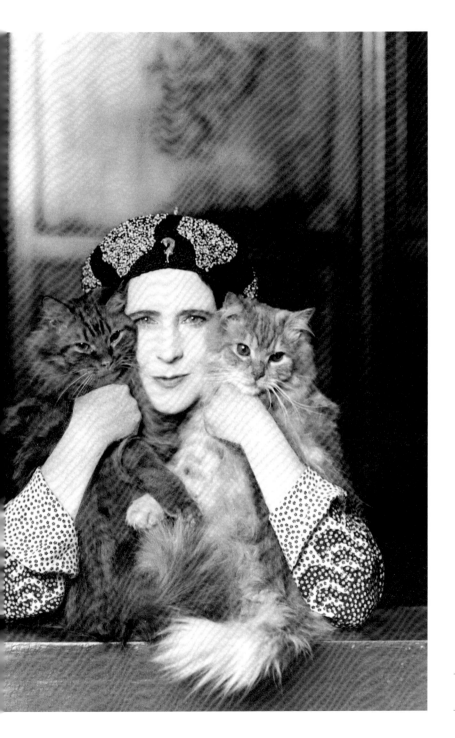

30. John Piper (1903-92)
By Peggy Angus, 1937
Pencil, crayon and wash, 52.1 x 62.5cm
(20¹/₂ x 24¹/₂")
NPG CP52

This careful and elegant drawing of the young John Piper is a reminder that in the 1930s he was at the heart of the modern movement in Britain and one of our leading abstract painters. He is sitting on an Alvar Aalto chair (1928) and behind him on the wall hangs his Forms on Dark Blue *(1936), one of his largest and most important works of the period. The artist, Peggy Angus, was married at the time to Piper's friend and collaborator, the architectural historian J.M. Richards. As editor of the* Architectural Review, *Richards commissioned articles and reviews from Piper, and in 1946 Piper illustrated Richards's study of suburban architecture,* The Castles on the Ground. *Piper was already working on the Shell Guide to* Oxfordshire *(1938) and with the publication of* Brighton Aquatints *in 1939, his transformation into the most significant British landscape and topographical artist of the century was complete. The one consistent fact about the huge variety of Piper's evocative landscape paintings is that they include neither people nor animals. It is unclear where this portrait is set, so the ownership of the ginger cat on his lap seems likely to remain unknown. The background may be his own house with the still unsold painting; it may be the Richards's, it may be Chermayeff's (Piper did a television programme with him on* Art and Modern Architecture *that January), or it may be purely imaginary, a suitable setting for a leading modernist. Whoever the cat belonged to and whether it invited itself into the picture or not, its role is clearly to add another element to the characterisation of Piper the man: modernists are not all bug-eyed monsters – sometimes they even like cats (and wear carpet slippers)!*

THE FACE
IN THE
CORNER

31. Vita Sackville-West (1892-1962) and Martha
By John Gay, 1948
Bromide fibre print, 29 x 22.4cm (11¹/₂ x 8³/₄")
NPG x47302

Daughter of Lord Sackville and brought up at Knole, one of the largest houses in England, Vita Sackville-West is better known for her unconventional marriage to the diplomat Sir Harold Nicolson and for the creation of the garden at Sissinghurst, where this photograph was taken, than as the prolific writer she had been since childhood. She had won the Hawthornden Prize for her long poem The Land *in 1926 and in 1930 became a best-selling author with her novel* The Edwardians, *still valued and read as a record of pre-First World War life in a great country house. Her literary career was interrupted by passionate affairs with a number of women, including Violet Trefusis and Virginia Woolf, but after moving to Sissinghurst in 1930 she became increasingly involved in the creation of the famous garden, contributing a gardening column to* The Observer *from 1946 to 1961 which was subsequently successfully anthologised.*

Her contemporary literary reputation may be gauged from the fact that John Gay took this photograph, published in July 1948, for a series of profiles of poets in the Strand Magazine. *The dignified and monumental combination of the statuesque figure, the ancient arch and urn and the noble dog conceals a hidden tragedy, for Martha, the German shepherd dog (then known as an alsatian), was already dying. Vita's companion of thirteen years, she had kept her company during Nicolson's weekly absences in London and the war years, but in April that year had suffered a heart attack. Harold had arrived to 'find Viti [sic] pacing by the lake in an agony of tears'. On 17 June Vita wrote to him, tormented by the eternal dilemma of whether to have Martha put down: '... when she comes and rests her nose on my knee and looks up at [me] with her golden eyes, so trustful, it makes me feel a traitor... You see I am essentially a lonely person, and Martha has meant so much to me. She was always there and I could tell her everything.' Three days later Martha was dead, buried in the wood at Sissinghurst, and Vita went to collect an alsatian puppy called Rollo. A week later, this photo appeared. Vita's last published work was* Faces: Profiles of Dogs *(1961) in which she remembered both her own and her friends' dogs: the saluki that Gertrude Bell had given her in Baghdad ('without exception the dullest dog I ever owned'), Ethel Smyth's Old English sheep dogs, and, of course, her beloved alsatians.*

32. Sir Alfred Munnings (1879-1959)
By Baron, *c.*1954
Modern bromide copyprint, 17.5 x 14.5cm (6³/₄ x 5³/₄")
NPG x21456

The only really successful British sporting painter of modern times, Munnings nevertheless worked in a derivation of Impressionism which he had learned from his great hero, John Singer Sargent. He lived at Dedham in the heart of Constable country, was a keen horseman and spent as much time at Newmarket as he did in his studio. Many of the most famous horses of the day, including Humorist, Hyperion and Brown Jack, were immortalised in his paintings. In 1949 he became perhaps the most controversial President of the Royal Academy ever, and his frequent attacks on modern art did much to enhance the Academy's reputation as a bastion of conservatism.

The photograph was taken in his studio at the same time as one for Tatler *magazine published in October 1954, and shows on the wall behind him his recently completed painting* Who's the Lady? HRH Princess Mary, *which was exhibited at the Academy the following year. Photographs of Munnings and Lady Munnings invariably show them with three or four dogs, but apart from his white mongrel Toby, to whom he devotes a lengthy eulogy, only a few of them are identified in his three-volume autobiography. This lively dog appears to be a labrador retriever with a bit of greyhound in him and is perhaps the same dog that stands in for Munnings in the satirical painting* Does the Subject Matter?, *an attack on modern art and on Sir John Rothenstein, Director of the Tate Gallery, which caused a storm of controversy two years later.*

33. Barbara Hepworth (1903-75)
By Ida Kar, 1954
Bromide fibre print, 30.4 x 30.6cm (12 x 12¹/₈")
NPG x31619

By 1954, when the Russian-born photographer went down to St Ives to photograph Barbara Hepworth in her studio, the sculptress was well on her way to becoming a figure of more than national significance. Her work had been included in the 1951 Venice Biennale and had also figured prominently in the Festival of Britain the same year. In 1952 a monograph with an introduction by her friend Sir Herbert Read had been published, and she had made a considerable impression as a stage designer for Electra *at the Old Vic. The occasion for this photograph was almost certainly the major retrospective at the Whitechapel Gallery in London that June which would do much to consolidate her reputation.*

Hepworth had moved to St Ives in 1939, and finally settled at Trewyn Studio in 1951 after her divorce from the painter Ben Nicholson. The photograph shows her in the carving yard with an early stage of the sculpture 'Curved Reclining Form, Rosewall', named after the hill outside St Ives from which she had conceived the sculpture. It was eventually purchased in 1962 for a piazza in a draughty civic development by the GPO in Chesterfield. With her children now grown up, and living on her own at the studio, cats seem to have played an increasingly important part in Barbara Hepworth's life. Three of them, Nicholas, Mimi and Tobey, are represented by their own photographs in her Pictorial Autobiography, *first published in 1970. A slightly overweight Nicholas, who was clearly a feature of studio life in the 1950s and early 1960s, is seen here making a surreptitious bid for inclusion in the limelight, and appears again in a later photograph of the finished sculpture in the garden at Trewyn.*

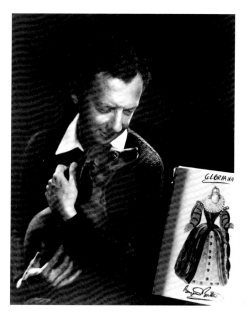

34. Benjamin Britten, Baron Britten (1913-76) By Yousuf Karsh, 1954
Bromide print, 33.9 x 26.9cm
(13 1/4 x 10 1/2")
NPG P490[14]

The son of a Lowestoft dentist, Britten's fame as a composer had rocketed to international levels after the success of his wartime opera Peter Grimes *(1945) and its three successors,* The Rape of Lucretia *(1946),* Albert Herring *(1947) and the all-male* Billy Budd *(1951). Always drawn to the sea, he settled in 1947 in the Suffolk town of Aldeburgh, where the following year he founded with his life-long companion, the tenor Peter Pears, the Aldeburgh Festival, which rapidly became a mecca for leading performing artists and audiences from around the world.*

Something of a celebrity himself, the Canadian photographer Yousuf Karsh got lost on the way to Aldeburgh in 1954, and with Britten irritated at his late arrival and insisting on playing tennis and going for a swim before he could be photographed, the session got off to a poor start. Then, wrote Karsh, 'the dog demanded to become part of the picture. Britten swivelled on the piano seat to make room for his canine collaborator, who leaped into the safety of his arms, while yet casting a wary eye on me.' Thereafter all must have been sweetness and light, for Karsh's two published photographs of Britten are among the best portraits of the composer. The score on the music stand is of his opera Gloriana *(1953), written for the coronation of Elizabeth II, and his next,* The Turn of the Screw *(1954) must by then have been in rehearsal for its première in Venice that autumn. The little dachshund is almost certainly Clytie, presumably originally Peter Pears's dog since she was named after his American singing teacher, Clytie Mundy, but she had clearly adopted the composer and appears in the portrait of him painted a few years later by their neighbour Mary Potter. By the time the Britten-Pears household moved in 1957 to The Red House, their final residence in Aldeburgh, there were two dachshunds, a situation which seems to have remained constant for the rest of Britten's life.*

35. The Duke (1894-1972) and Duchess (1896-1986) of Windsor
with Dizzy
By Dorothy Wilding, 1955
Modern bromide print from original negative
NPG x27966

Dizzy (short for Disraeli) was the first of nine Windsor pugs and joined the
Duke and Duchess's household in France soon after their return from
wartime governorship of the Bahamas in 1945. With them had come Pookie,
last in line of a succession of cairn terriers that had begun with Slipper,
whom the Duke, then Edward, Prince of Wales, had presented to Wallis
Simpson for Christmas 1934. The Duke had clearly inherited the Royal
Family's love of dogs, apparent from his grandmother Queen Victoria
onwards, and Slipper appears in a number of pre-war photographs by
Dorothy Wilding, both with him and with the Duchess. Slipper rather
ominously died of snakebite shortly after the abdication and before the
fateful wedding.

Responsibility for usurping the cairn terriers' hold on the Windsors'
affections clearly lies with Dizzy, and they took to pugs with something of
an obsession. In the sale catalogue of the Windsors' effects were several
silver-plated dog bowls, engraved collars, pug bed-linen and a whole host
of 'puggiana', including paintings and Meissen figurines. This photograph
was taken in Dorothy Wilding's studio in New York, where the Windsors
had an apartment and where their pugs were often proudly paraded in
national dog shows.

36. Madame Yevonde (1898-1975)
Self-portrait photograph, c.1960
Bromide print, 36.2 x 28.5cm (14¹/₄ x 11¹/₄")
NPG x26030

Although still a little-known name, Madame Yevonde (she was born Yevonde Cumbers) was one of the most colourful and original figures in British photography. Her pioneering work with colour photography in the 1930s was extremely influential and has scarcely been equalled since. This entertaining self-portrait is typical of her always inventive approach to the medium and surely indicative of the importance cats played in her life. She had been happily married to a minor playwright called Edgar Middleton and was devastated by his premature death in 1939. Although not mentioned at all in her entertaining biography In Camera, *it was her cats who seem increasingly to have filled the void left by his death.*

The cats had the free run of her studio. Whiskey wormed his way into several of her society portraits in the 1930s and it was probably he who managed to escape with her to safety seconds before a direct hit on her Berkeley Square studio during the Blitz. Junior also appears in other photographs. On the reverse of the mount, Mme Yevonde has inscribed: 'JUNIOR – Winner of the 1958 Good Conduct Prize offered by the Cats Protection League for the most distinguished cat. He was aged 18 when he disappeared. He is wearing a very early photograph of the photographer.' Modest as always, the photograph in question cannot in fact have been taken much before 1945.

37. Edith Sitwell
(1887-1964)
By Mark Gerson, 1962
Bromide print,
25 x 20cm (9³/4 x 7³/4")
NPG x46700

During her lonely and unloved childhood in the ancestral home at Renishaw, the redoutable poetess often felt that her only friends were the animals and birds she adopted. There was Peaky, the Renishaw peacock with whom she 'walked round... with my arm around his lovely neck, that shone like tears in a dark forest...' until 'my father bought Peaky a wife (in my eyes a most dull and insignificant bird) and he discarded my companionship... It was my first experience of faithlessness.' There was also a puffin with a wooden leg and 'a baby owl that had fallen out of its nest, and which used to sleep with its head on my shoulder, pretending to snore in order to attract mice'.

In later life, however, it was cats who shared Dame Edith's life. She was indefatigable in her devotion to them, writing vociferous letters to newspapers and even notes in her address book about cruelty cases. A cat she had had to leave in Paris in 1939 was regularly sent money for his food and frequent reports on his health were required in return. By 1962 she was living in a flat in Hampstead with four cats, Shadow, a Siamese, two adopted strays, Orion and Belaker, and her favourite, the cream-coloured Leo. The photographer Mark Gerson, who came to photograph Dame Edith for an article in Books and Bookmen, *also photographed Leo on his own. 'You have made him look so majestic,' she wrote, thanking him for his gift, '... that I think, no matter how fine your photographs of me may be, it is* Leo *who ought to figure on the cover of Books and Bookmen.' As it is, the glimpse of wheelchair, Dame Edith's still powerful profile and Leo's gentle acquiescence add up to a touching image of resilience in old age and fading greatness.*

38. Max Wall (1908-90) with Onde
By Maggi Hambling, 1981
Oil on canvas, 91.4 x 66cm (36 x 26")
NPG 5578

For nearly two years of her life, from spring 1981 to early 1983, Maggi Hambling devoted herself almost entirely to fifteen paintings and quite as many drawings of the 73-year-old comedian and entertainer Max Wall. A stand-up comic and entertainer in the old Vaudevillian tradition, his career had gone through the doldrums in the 1950s and early 1960s, but by the time she first met him he was increasingly being recognised as a serious actor of considerable power, especially for his appearances in roles like Vladimir in Samuel Beckett's Waiting for Godot *(1977/1981). In early 1981, while Maggi was Artist in Residence at the National Gallery, Max was performing in a revival of his one-man show* Aspects of Max Wall *across the Charing Cross Road at the Garrick Theatre. She went to see him twice and, bowled over, plucked up courage and wrote to him.*

The relationship that developed between the 35-year-old artist and the veteran vaudevillian does not, in retrospect, seem surprising to anyone who knows Maggi's single-minded devotion to her work and to her friends. When Max asked her why she was doing all these paintings of him, she could only reply, 'Because you inspire me.' The afternoon sittings and late-night drinking and eating (when he was not performing) became a regular feature of her Battersea studio, also shared by her three cats. Onde, Onde's brother Parole and Mr Smith all put in an appearance in one or other of the widely diverse and imaginative Max Wall paintings. Max with Onde, *the second in the series, is probably the least theatrical and is based on a drawing from the first sittings. During rests, Max would tell stories and jokes, do conjuring tricks and sing songs. The painting captures the moment when he had just finished singing 'Poor little rich girl' to Onde, who had been fussy about eating her tea, the magic of the event still tangible in the air – performer and recipient united in silent reflection. Onde, who had made an earlier appearance in the Gallery's self-portrait by Hambling (1978), had originally come to stay for six months but remained for the seventeen and a half years of her life. Like many of the animals in Hambling's work, she is here also a personification of the artist.*

39. HM Queen Elizabeth II (b.1926)
By Michael Leonard, 1986
Oil on canvas,
76.2 x 61.6cm (30 x 24¹/₄")
NPG 5861

This vivid and cheerful portrait of the Queen was commissioned by Reader's Digest *magazine from a leading British photorealist painter to celebrate Her Majesty's sixtieth birthday. The artist, Michael Leonard, said that he 'wanted to give the viewer a feeling of having a conversation with the Queen'. Cheered no doubt by having a favourite corgi to share her ordeal and only having to pose for photographs (from which the portrait was painted), this is indeed one of the most extrovert and approachable of all the many paintings that have been made of the Queen. The setting is the Yellow Drawing-room at Buckingham Palace (the same as for Bryan Organ's portrait of Princess Diana) and the corgi's 'red-gold coat became the colour key for a picture largely made up of variations on gold – a scheme I hoped would help to convey a feeling of royalty combined with human warmth'. The corgi was the eight-year-old Spark, whom the Queen herself chose to bring along to the sittings, '... possibly because of her obedience and good nature... Spark was a great asset at the sittings. She did all that was asked of her and provided the occasion for Her Majesty to adopt a pose that was unforced and natural, lending the composition a degree of liveliness and movement.'*

Spark was not the first royal corgi to appear in a portrait of the Queen at the National Portrait Gallery. One can be seen sleeping on the floor in Sir James Gunn's 1950 Conversation Piece at Royal Lodge, Windsor, *a painting of King George VI and his family. It was in 1933, when he was Duke of York, that the King first bought a Pembroke Welsh corgi, called Dookie, as a pet for his two young daughters. Originally used for droving cattle, Pembrokeshire corgis are an ancient Welsh breed and are slightly smaller and – partly due to their royal patronage – better known than Cardigan corgis. Dookie was joined by Jane in 1938 and soon after by their puppies, Crackers and Carol. The Queen grew up with these corgis, and she and the Queen Mother have remained attached to them ever since. Spark belonged to the tenth generation of corgis descended from Susan, a bitch from a Cambridgeshire kennels who was given to the Queen for her eighteenth birthday in 1944.*

40. Sir Emmanuel Kaye (b.1914)
By Paul Brason, 1991
Oil on canvas, 106.8 x 91.4cm (42 x 35")
NPG 6158

Of the many portraits commissioned by the Gallery in recent years, only two have included portraits of the sitter's pets. Sir Emmanuel Kaye, a noted industrialist and philanthropist, had originally suggested Paul Brason, a former Portrait Award winner, for the job since he had admired the artist's double portrait of Sir Roy Strong, showing both the professional and the personal sides of the sitter's life. Unwilling to repeat exactly the same formula, Brason suggested the imaginative compromise seen here of using Sir Emmanuel's reflection in the plate glass window, apparently looking out into the garden towards his beloved golden labrador, Barley. A connoisseur and collector as well as a keen animal lover, Sir Emmanuel was anxious that the caption on the portrait when it was unveiled should make it clear that the bird in the cage was an antique mechanical canary and not a real one.

Barley was five years old when the portrait was painted and had been acquired from a shop in Sir Emmanuel's local town of Odiham, Hampshire. Labrador retrievers originally developed, as the name suggests, on the coast of Canada, where they were used for helping to haul in the fishermen's nets. Popular as a gundog since the latter half of the nineteenth century, the breed is known for its responsiveness and in recent years has been much used as a guide dog and for detecting drugs and explosives. Indeed, at the age of one year, Barley himself was pronounced by a leading dog-behaviour specialist to be 'a dream dog'.

ACKNOWLEDGEMENTS

I am especially grateful to the
natural historian and author
David Alderton, whose comments
on the identification of the
various dog breeds were invaluable
(and saved me in particular
from finding Newfoundlands
wherever I looked). I must
also thank Maggi Hambling,
Sir Emmanuel Kaye and
Paul Brason for information
on their portraits, and my colleagues
at the National Portrait Gallery,
especially Catharine MacLeod,
Jacky Colliss Harvey and
my editor, Ariane Bankes.